GW00771315

ROCHESTER
THROUGH TIME
Robert Turcan

AMBERLEY PUBLISHING

'Whether I shall turn out to be the hero of my own life, or whether that station will be held by anybody else, these pages must show.'

Charles Dickens – *A Tale of Two Cities*

To Charlotte and all the daughters of Rochester

First published 2011

Amberley Publishing
Cirencester Road, Chalford,
Stroud, Gloucestershire, GL6 8PE

www.amberley-books.com

Copyright © Robert Turcan, 2011

The right of Robert Turcan to be identified as the Author of this work has been asserted in accordance with the Copyrights, Designs and Patents Act 1988.

ISBN 978 1 84868 270 2

British Library Cataloguing in Publication Data.
A catalogue record for this book is available from the British Library.

Typeset in 9.5pt on 12pt Celeste.
Typesetting by Amberley Publishing.
Printed in the UK.

Introduction

Rochester is an historic town of great charm. Its skyline is dominated by its castle and cathedral. While at ground level the quaint High Street is the main focus of attention. It follows the route of the Roman road called Watling Street. Where it meets the river Medway a bridge has existed for many centuries. Indeed, the strategic importance of this crossing, on the London to Dover route, was the predominant reason for population settlement and growth.

A Roman fort and walled garrison existed here to protect the first rudimentary structure. Later, when the Normans invaded, their leaders directed the construction of a magnificent castle keep. It was soon followed by a splendid cathedral.

By Tudor times, the Royal Navy expanded shore-based facilities here and established, at Upnor, a castle to guard them from invaders. These fortifications did not, however, prevent an opportunistic Dutch raid in the late seventeenth century. By the 1700s, adjacent Chatham dockyard was expanding so rapidly and on such a large scale that its ship building production made it one of the largest industrial complexes in the world.

Armament manufacture and engineering excellence are, even today, vital economic factors in the Medway towns. Steam rollers and traction engines were turned out in their thousands during the late Victorian and early Edwardian years at Aveling and Porter's Strood factory. Later a firm called Wingate took over this site for heavy engineering output mainly associated with the cement and concrete industry. Local deposits of chalk and brick-earth also meant that the area became a significant supplier of building materials for the metropolitan explosion of mid-nineteenth century London.

This Capital, with all its teeming echelons of society, was depicted and graphically brought to life in the stories of Charles Dickens – a local legend. This major-domo of the English novelist's childhood

was largely spent in Chatham and Rochester because his father was locally employed as a Naval Pay Clerk. Romantically, at the zenith of his career, he was to fulfil an infant dream of purchasing Gads Hill House in a nearby village. Today, 199 years after his birth, his life and work are celebrated in Rochester with the annual Dickens Festival. Moreover, many local shops and cafés commemorate the larger than life characters he created in his literature by naming their businesses after them. Hopefully, plans by denizens to erect a statue to mark the bi-centenary of his birth will reach fruition in 2012.

In fact, upon reflection, there is little doubt that the people of Rochester will react positively as this town is something of a cultural centre. Its streets abound with bookshops, artist's suppliers and galleries. A healthy regard for a rich heritage is displayed in the excellent state of preservation of its myriad listed buildings. There is also a vibrant trade in antiques and junk outlets. Happily, some of these supplied the aged postcards which partly illustrate this book and, when juxtaposed against modern images, show how successfully Rochester has maintained an attractive, dignified and yet vivacious environment in which to live and work. May this ancient place soon be graced with its correct 'City' status; so casually, and mindlessly, lost in local government reorganisation. Surely then, with its renowned medieval flagship buildings, it can stand proud throughout time.

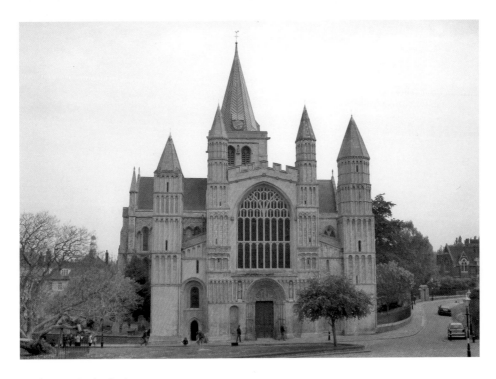

Rochester Cathedral

Rochester Cathedral is England's second oldest cathedral and was founded by Bishop Justus in AD 604. He was one of the original missionaries who accompanied Saint Augustus of Canterbury to convert the pagan English to Christianity. By Norman times, Bishop Gundulf, who was a talented architect, had a tremendous influence on its future development. In the early medieval times, however, a series of fires caused considerable damage and interference to construction work.

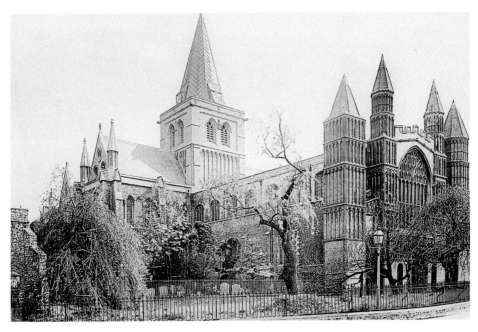

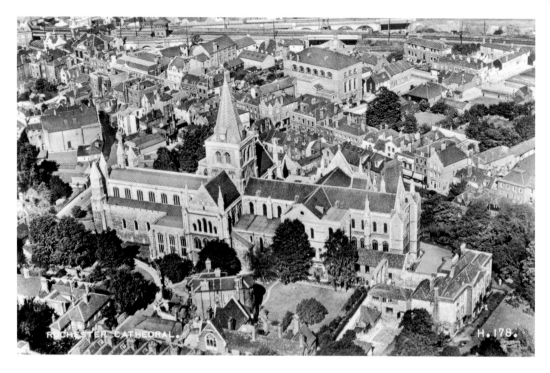

Aerial Views of Rochester Cathedral and Precincts

This sepia photograph of Rochester Cathedral was taken in 1955. It was shot from the south and shows the line of Watling Street, and the viaducts of the main line railway behind. The contemporary picture below, from the opposite angle, also illustrates the beautiful symmetry of this magnificent medieval building. It also shows how its setting amid well-maintained open spaces and lovely Georgian buildings has been conserved.

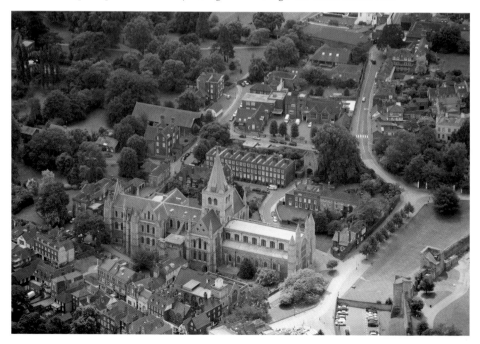

Western Entrance to Rochester Cathedral

The ornately carved main entrance to Rochester Cathedral depicts Christ sitting in glory at the centre of the tympanum with Justus and Ethelbert flanking him on either side. A hundred years ago this feature was protected by a full set of railings, whereas now, only the columns are protected.

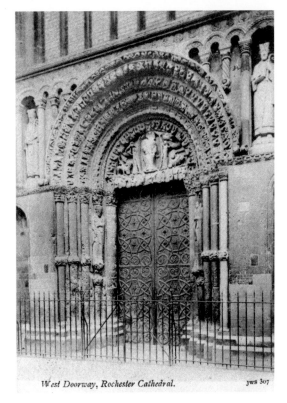

West Doorway, Rochester Cathedral. jws 3o7

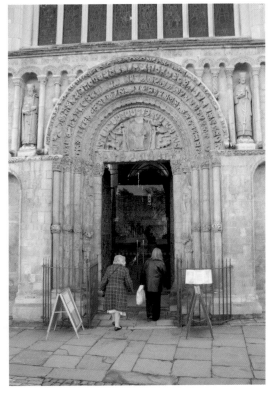

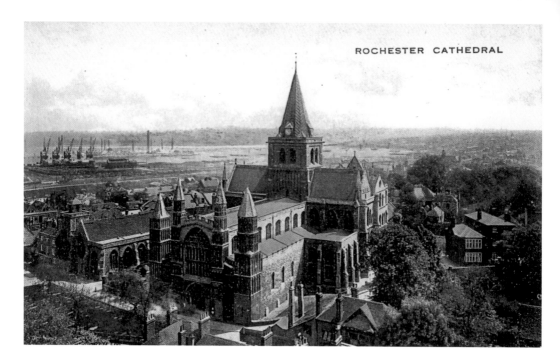

ROCHESTER CATHEDRAL

Edwardian Postcards of Rochester Cathedral

After the Dissolution of the Monasteries, the cathedral suffered a steep decline. Neglect was such that by the seventeenth century, Samuel Pepys, who was an Admiralty official at the nearby Chatham dockyard, dismissed it as a shabby place. By Edwardian times, however, there had been considerable restoration work completed. Lewis Nockalls Cottingham and Sir George Gilbert Scott were the two renowned architects responsible for this during the nineteenth century.

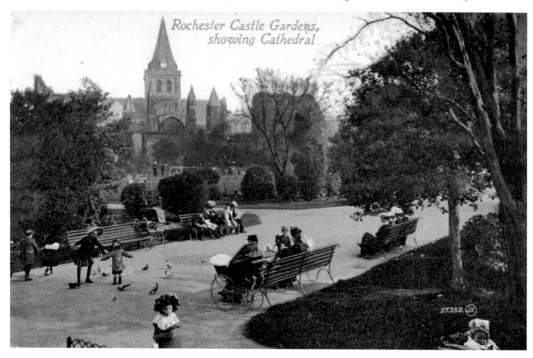

Rochester Castle Gardens, showing Cathedral

Workers' Memorial Tree

The trade union Unison have planted a mulberry tree in Rochester Castle grounds to commemorate all those who have lost their lives at work or due to industrial diseases. The foliage and plaque are pictured here bathed in autumn sunlight.

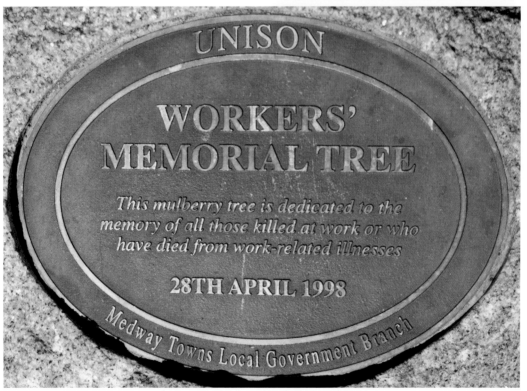

UNISON

WORKERS' MEMORIAL TREE

This mulberry tree is dedicated to the memory of all those killed at work or who have died from work-related illnesses

28TH APRIL 1998

Medway Towns Local Government Branch

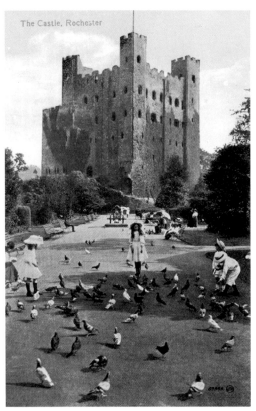

The Castle, Rochester

Rochester Castle Keep
Rochester Castle was established following the Norman invasion. It guarded the point where the old Roman road of Watling Street (A2) crossed the River Medway. The great keep pictured here is one of the largest in England. Its walls, of 12-foot thickness, are built to a height of 113 feet on a 70-foot square.

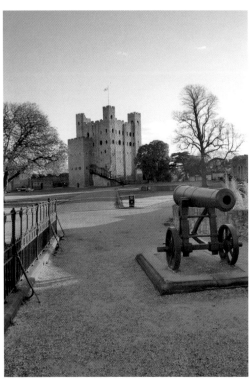

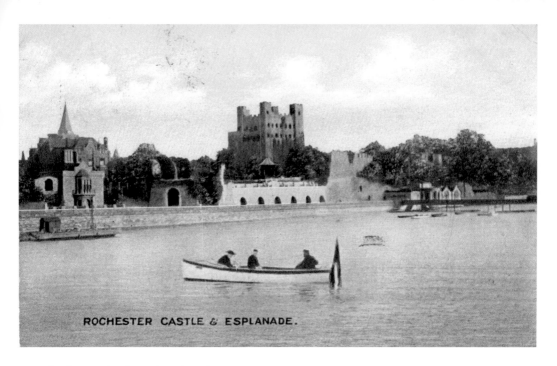

ROCHESTER CASTLE & ESPLANADE.

Rochester Castle and Esplanade

These views from the River Medway show how little has changed in this area over the past century. The much-loved skyline of cathedral and castle are instantly identified as Rochester's unique architectural signature.

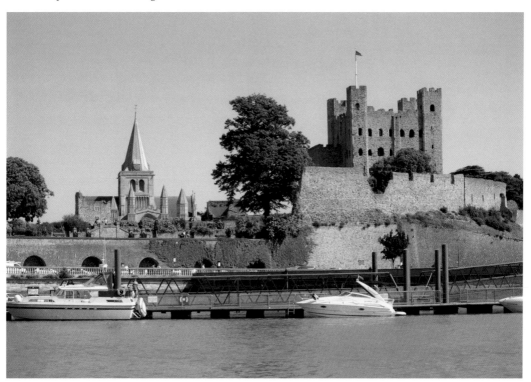

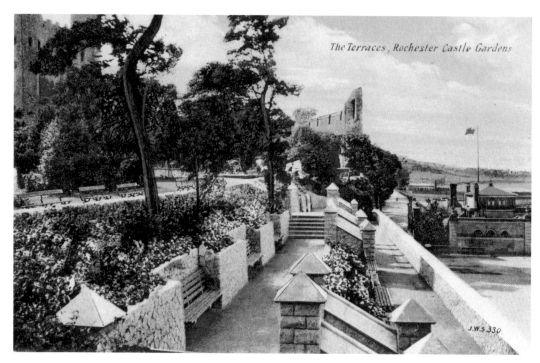

The Terraces, Rochester Castle Gardens

J.W.S.330

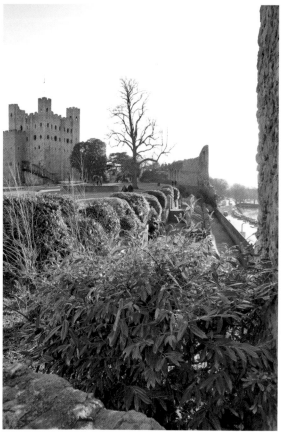

Esplanade Gardens

The esplanade gardens have always been a picturesque spot to promenade and appreciate the riverside view. However, these two photographs show how municipal gardening fashions have evolved over a hundred years from formal flower beds to more informal shrubberies.

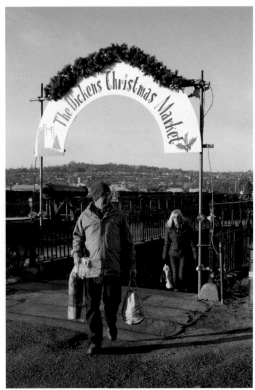

Rochester Dickens Christmas Market
Rochester has a number of festival activities which highlight the town's close links with England's most famous Victorian author. A relatively new one is the Dickens Christmas Market, which replicates a typical German Christmas market for seasonal fare. For additional atmosphere a small German oompah band is hired to entertain shoppers.

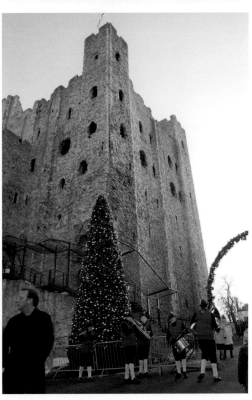

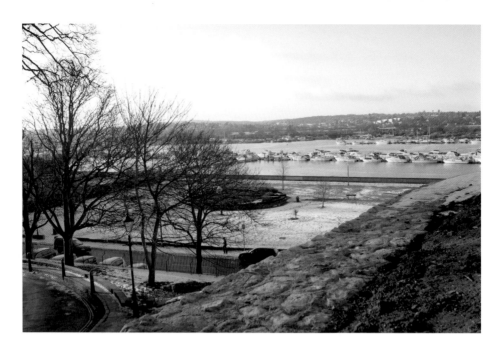

Rochester Cruising Club

Founded in 1905, Rochester Cruising Club had disused barges for its headquarters before building a clubhouse on Medway Council land in 1937. A replacement was erected in 1974 and extended in 2005 – its centenary year. The majority of sailing craft are unable to pass the fixed bridge at Rochester. However, owners of motor craft have over 19 miles of navigable river available upstream to Tonbridge. The snapshot above shows members' boats moored on pontoons, while below a much earlier close-up shot shows the pier and esplanade balustrade – recycled from parts of the old demolished stone bridge.

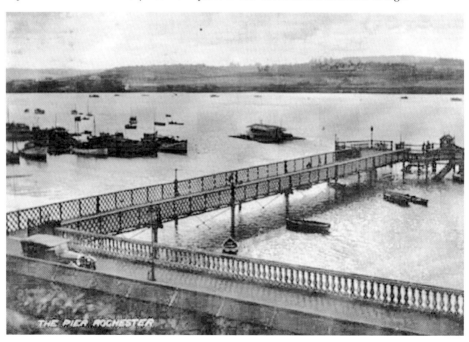

THE PIER ROCHESTER

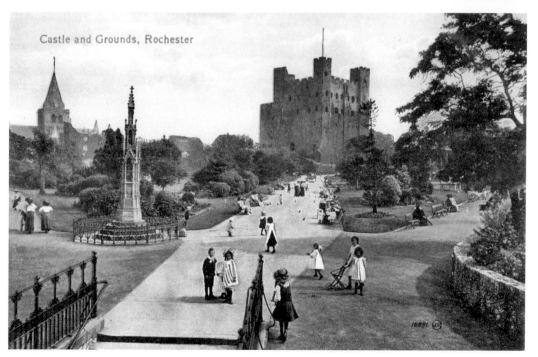

Outer Bailey and Keep

In 1215, King John personally led a siege against Rochester Castle, which was under the command of William de Albini and Reginald de Cornhill and some hundred or so rebellious barons. After a ferocious battle, the south curtain wall was breached. However, it took extensive work by sappers to undermine and then burn the south-east tower before the seven-week attack succeeded. From the aerial photograph above, you will see that when this tower was repaired it was made circular to deflect missiles.

Castle and Grounds, Rochester

15

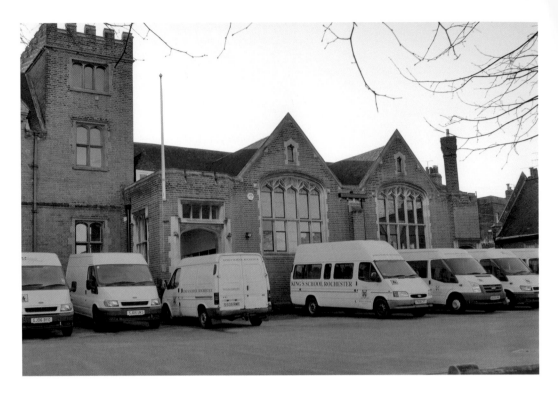

King's School, Rochester

The King's School, Rochester, is the second oldest school in the UK. It was founded in AD 604 as a cathedral school and its governing body is still chaired by the Dean of Rochester. The school buildings, pictured above, are on Boley Hill in close proximity to the cathedral precincts, but the school is spread around the town with the Maths and Classics Departments housed in Old St Margaret's, an ex-workhouse.

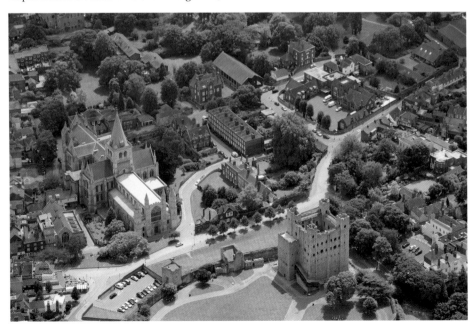

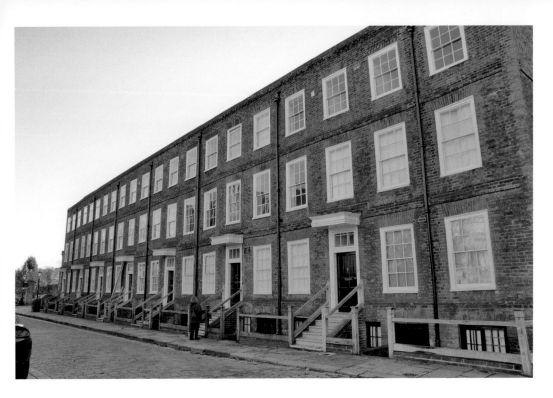

Minor Canon Row

Minor Canon Row is an exceptionally fine early-Georgian terrace built in 1722/3 for cathedral clergy. It has been acquired by the Spitalfields Trust who will supervise major restoration work. Just visible in the above picture is a plaque on No. 2, which was the childhood home of Dame Sybil Thorndike, whose father was a Minor Canon, 1886–92.

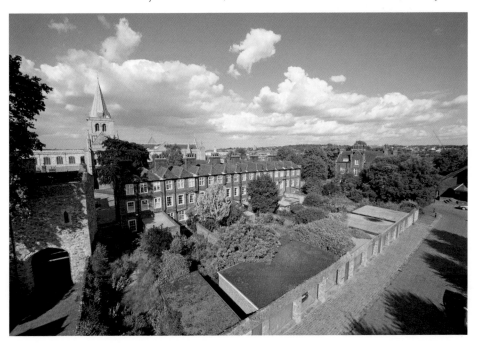

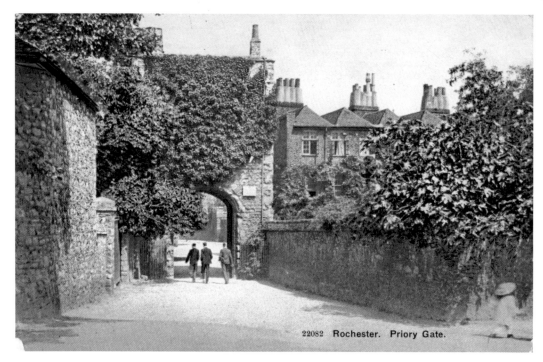

22082 Rochester. Priory Gate.

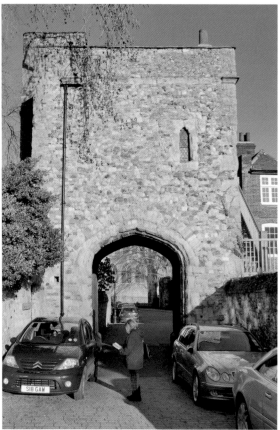

Priory Gate

Now without creeping ivy, Priory Gate near Canon Row has remained unaltered over the past hundred years. It was once used by choristers for practice sessions.

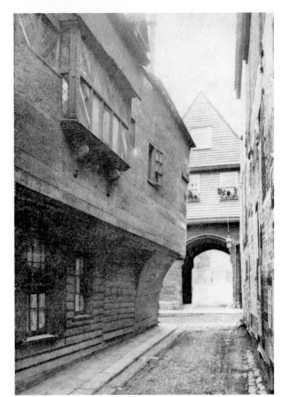

Chertsey's Gate
Chertsey's Gate was built of alternating courses of stone and flint in the early fifteenth century. It separated the walled cathedral precincts from the town. However, by the eighteenth century, it had been converted into a dwelling by the addition of a timber house on top of it.

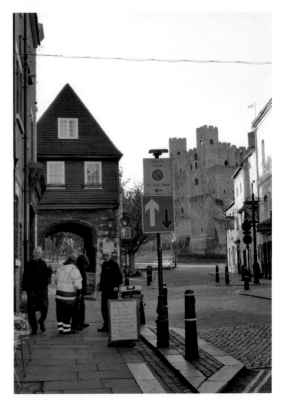

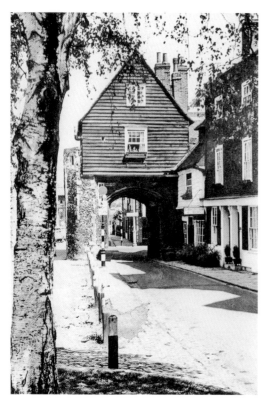

Chertsey's Gate, Facing East
The area south of Chertsey's gate is the approach road to the cathedral's magnificent western façade. It is a popular place for cosy tearooms and an assembly area for church parades.

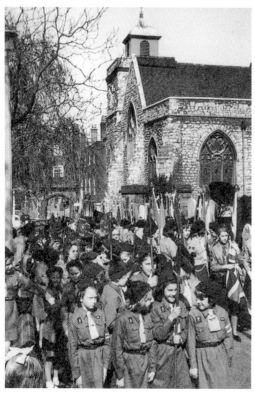

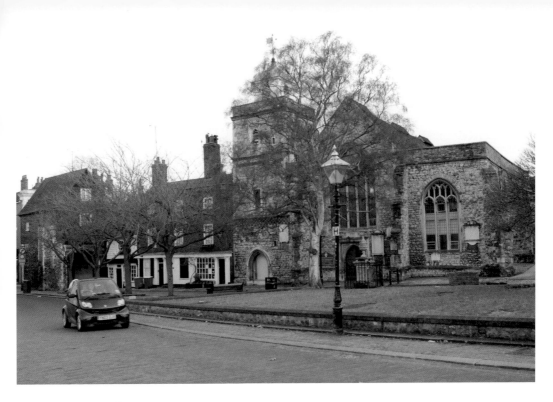

St Nicholas Church

The church of St Nicholas alongside the cathedral was built for the townsfolk in 1423, after quarrels with the monks of the priory over use of the cathedral. It was rebuilt in 1624, and in 1964 was converted for use as administrative offices for the Diocese of Rochester.

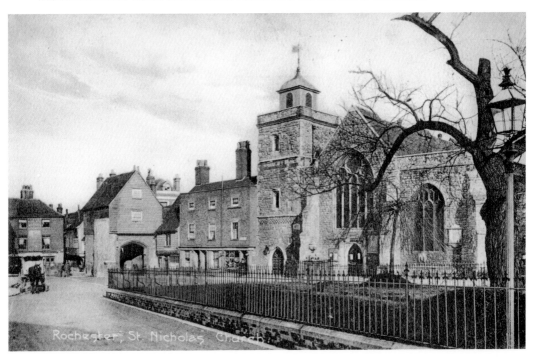

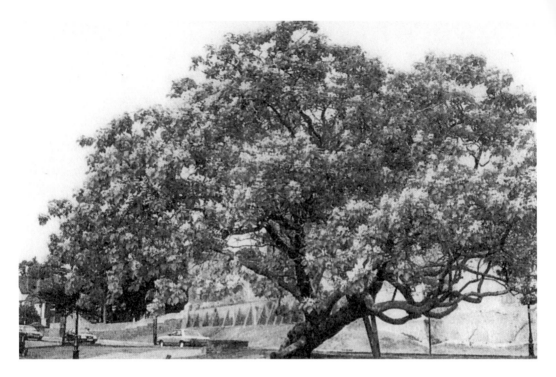

Catalpa Tree

The catalpa tree in front of Rochester Cathedral is around 150 years old and is possibly England's second oldest tree of this species. It is currently the subject of a public appeal for £22,000 to undertake tree surgery and improvements to its environment.

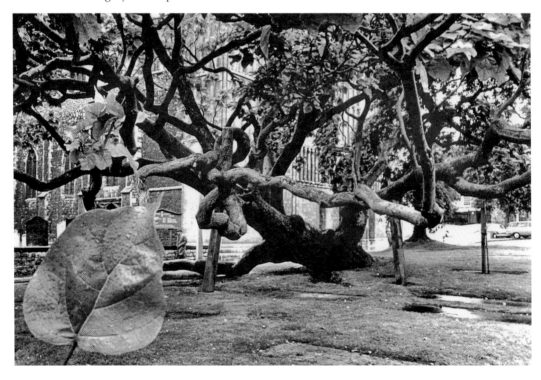

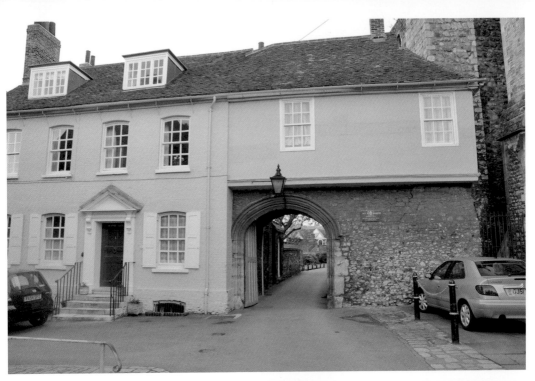

Cathedral Environs

The buildings and grounds around Rochester Cathedral are in perfect harmony. These pictures give a good example of Georgian housing abutting medieval stonework without any stylistic clash.

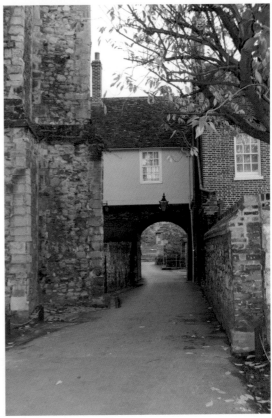

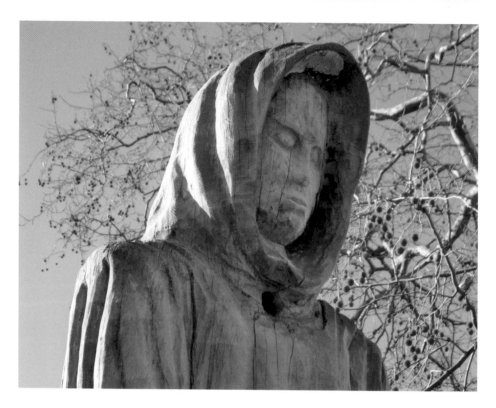

The Great Storm of 1987

The photograph below shows the scene of devastation at the Vines following the Great Storm of 1987, which battered the south-east of England with gale force winds. Many of the ancient plane trees were damaged and uprooted. To commemorate this event, one of the remaining tree stumps was carved into the form of a monk whose vineyard existed here in medieval times.

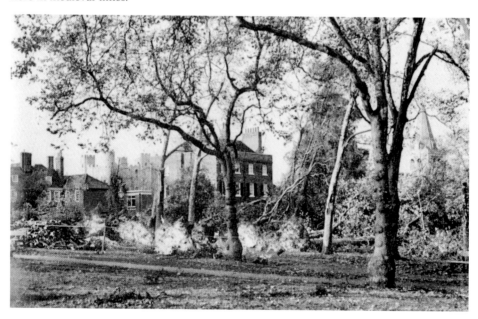

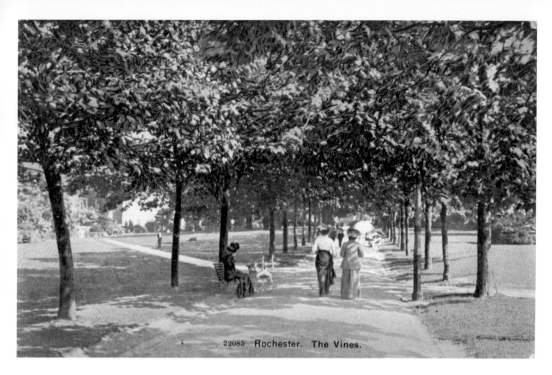

22085 Rochester. The Vines.

The Vines

As a public park the Vines dates from 1880. It provides a secluded retreat from the noise and bustle of the High Street in Rochester. Thankfully, its elegant, arcadian character remains unchanging.

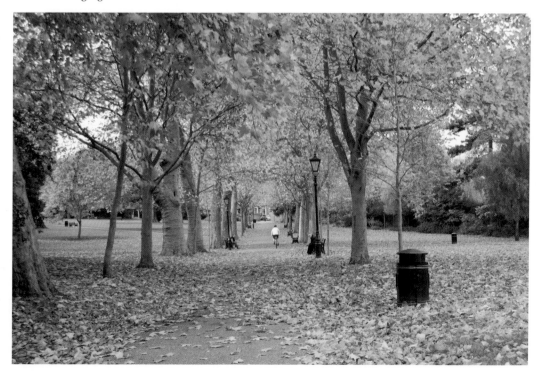

Period Doorways at the Vines

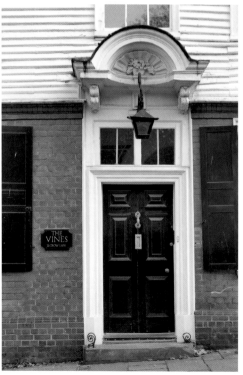

These snapshots are examples of many historical features adorning listed properties around the Vines. The area is part of a larger conservation scheme and is particularly popular with residents seeking character homes.

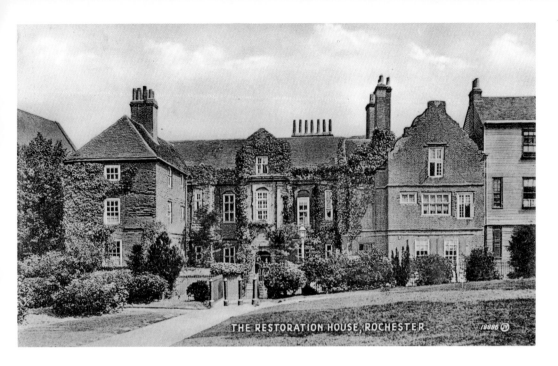

THE RESTORATION HOUSE, ROCHESTER

Restoration House

This fine Elizabethan mansion overlooks the Vines. It was here that Charles II rested on his journey from the Continent to reclaim his kingdom. Rod Hull, the entertainer, bought the property to save it from becoming a car park, but it was confiscated to pay a tax bill. Its current owners have completed a very sympathetic scheme of restoration and are happy to open the house and garden for occasional public access.

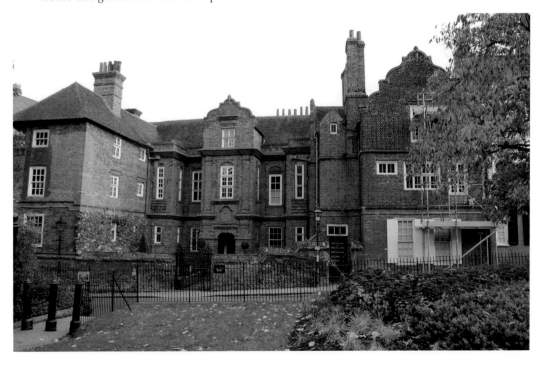

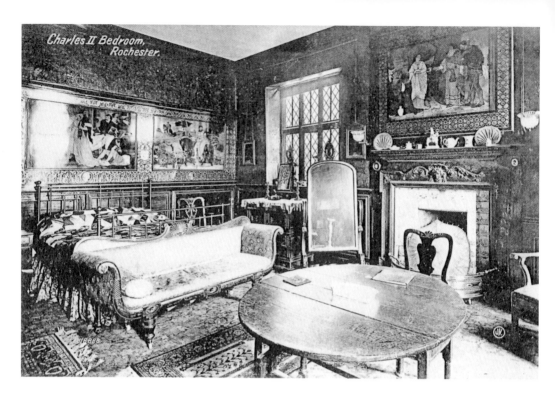

Historic Interiors

The picture above illustrates the actual bedroom in which Charles II slept at Restoration House. He was presented with a silver basin and ewer by the city council to show their allegiance and gratitude on his return to the English throne. Below is an old scene from Eastgate House in the High Street, when it was a public library.

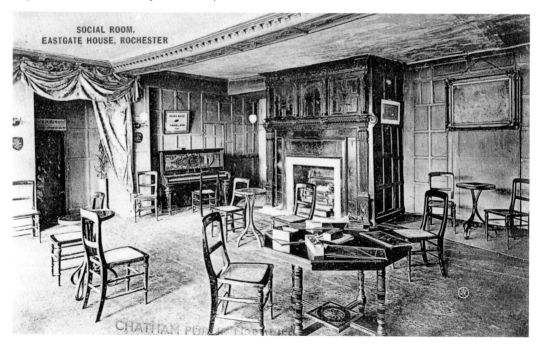

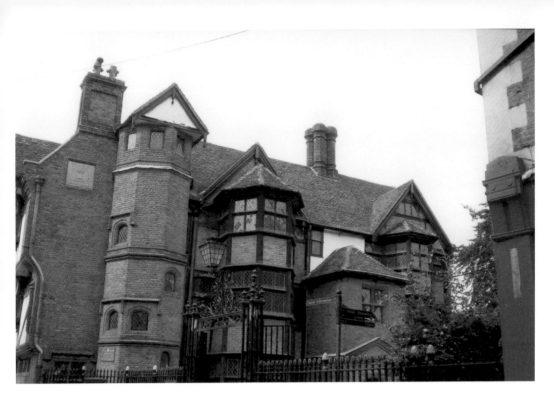

Eastgate House

This impressive Elizabethan town house was built for Sir Peter Buck in 1590. The family of this high ranking naval official lived here for five further generations until, in the eighteenth–nineteenth centuries, it became a girls' school and then a museum. By 1970, its owners, Rochester Corporation, had made it into the Charles Dickens Centre. This was closed in 2004 and now this splendid Grade I listed building can be hired for weddings and sundry exhibitions. Recently, lottery funding has been granted to fund restoration.

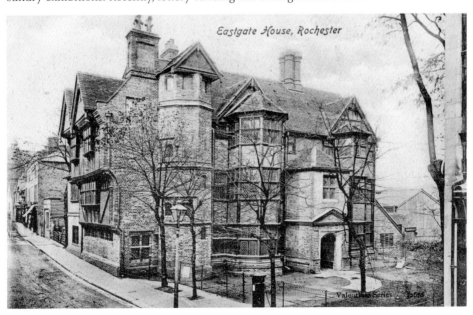

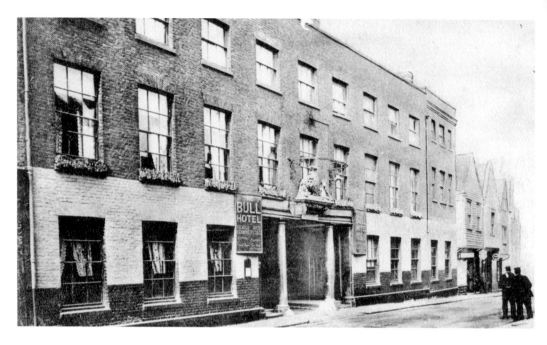

The Royal Victoria and Bull Hotel

This four-hundred-year-old coaching house was a favourite of Charles Dickens. Queen Victoria was also a patron on her travels to the Kent coast. The wide central entrance evokes an era when stagecoaches drawn by six horses would have clattered into the stableyard beyond.

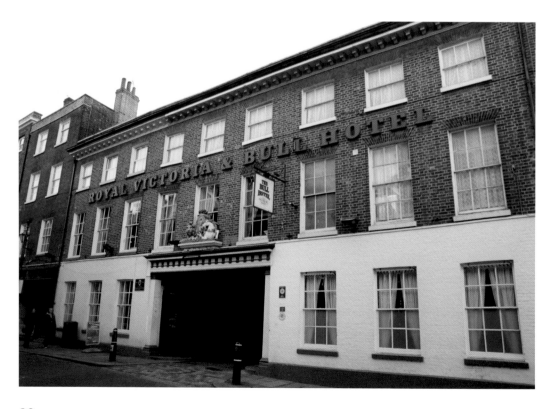

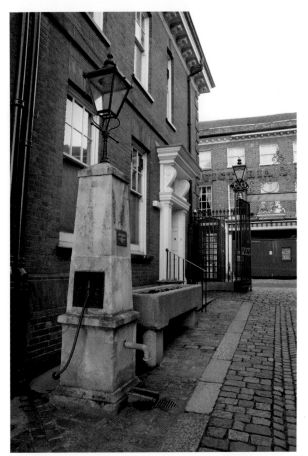

Water Pump
In an alley next to the Guildhall Museum an old hand water pump from the High Street has been re-sited. It once supplied drinking water to the multitude of draft horses travelling along Rochester's main thoroughfare.

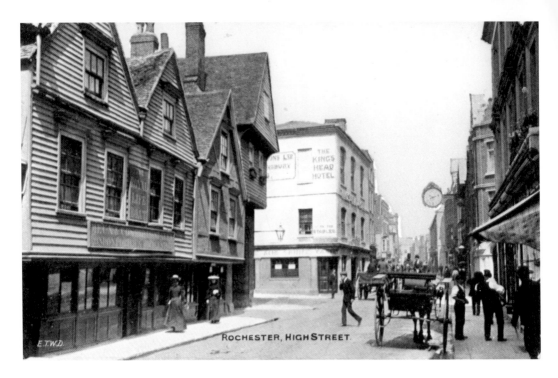

ROCHESTER, HIGH STREET

Kings Head Hotel

The Kings Head Hotel has been a prominent Rochester hostelry since 1656. Old panelling and a lead-light window survive to indicate the building's age. Being close to the cathedral, the choir boys were occasionally treated to tea and games here by their masters.

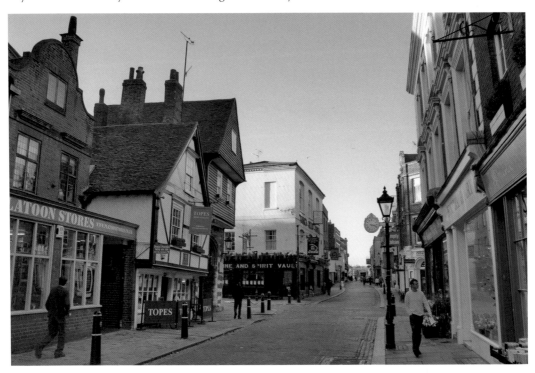

Mollycoddles

This attractive shop is one of the many specialist retail outlets along Rochester High Street. These period buildings and inviting alleyways combine to make an interesting shopping experience.

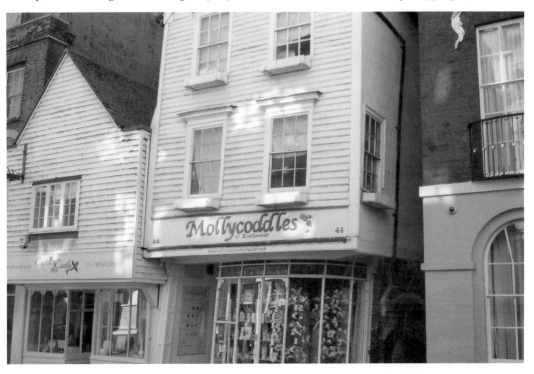

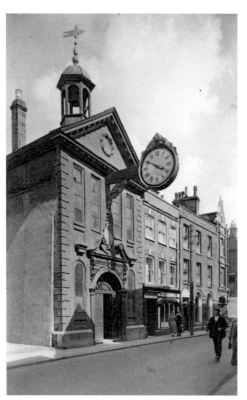

The Old Corn Exchange

The Corn Exchange was erected from funds donated by its standing Member of Parliament, Sir Cloudsley Shovel, 1695–1708. Distinguished with success in many sea battles during his relatively short naval career, he was drowned at sea off the Scilly Isles in 1708. Although the Admiral may not have had much opportunity to visit the constituency he was, however, entertained to a dinner given by the mayor in 1701. The total bill for this meal came to some £15, with two thirds spent on wine alone! Later, in the eighteenth century, the high-spirited William Hogarth and his chums are recorded as playing hopscotch on the pavement here during their peregrinations of north Kent. Thereafter, in the nineteenth century, Dickens refers to this landmark building in his lesser-known work *The Uncommercial Travellers.*

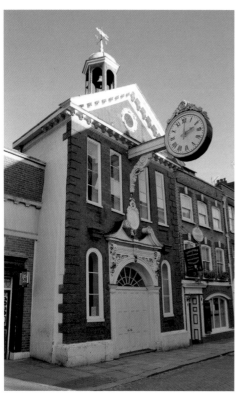

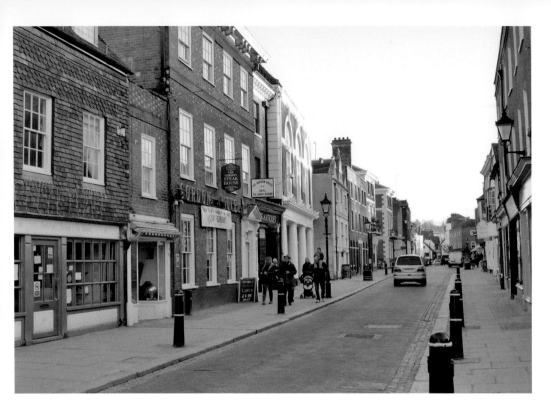

High Street, Rochester

The High Street was once a congested main highway jostling with trams and horse-drawn vehicles. Now that the trunk road has been diverted north near the railway, and since the M2 motorway was constructed, it is a haven for antique shops and popular cafés.

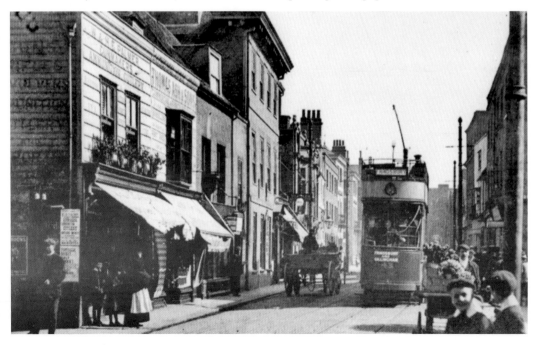

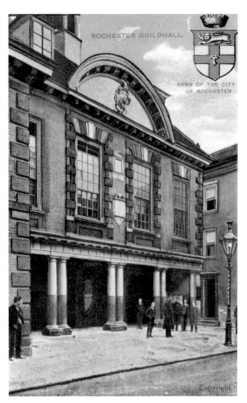

ROCHESTER GUILDHALL.

ARMS OF THE CITY
OF ROCHESTER

The Guildhall

The Guildhall was built in the late seventeenth century on land leased from the Rochester Bridge Wardens. Its fine cupola and impressive galleon weathervane were added in 1780. Inside there is a grand staircase leading to a large assembly hall with beautiful decorated ceiling. Upon the walls hang valuable portraits, including paintings of William III and Queen Anne by the celebrated artist Sir Godfrey Kneller. Not always used for solely aldermanic purposes, the mayor authorised a £20 penalty for tumultuous, riotous and disorderly misuse in 1753! The freehold was purchased in 1864 for £1,000 to avoid excessive ground rent. Now a much visited museum, it houses the City Regalia along with a life-size exhibition showing life on a Napoleonic ship's hull, moored in the Medway.

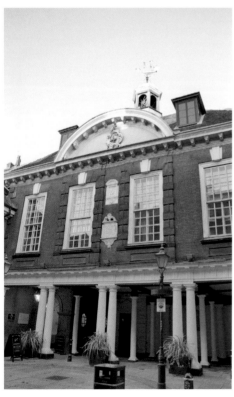

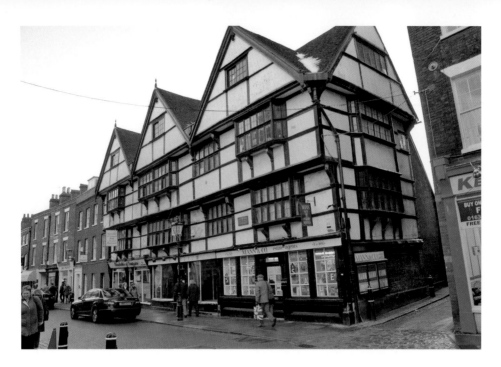

Rochester Lower High Street

Opposite Eastgate House stands this elegant three-storied, multi-gabled terrace. It is yet another site mentioned in the tales of Charles Dickens. A plaque adjacent to one of the oriole windows mentions this fact. The snapshot of heavy traffic in the 1970s shows how the more pedestrian-friendly scheme of today has enhanced this area considerably.

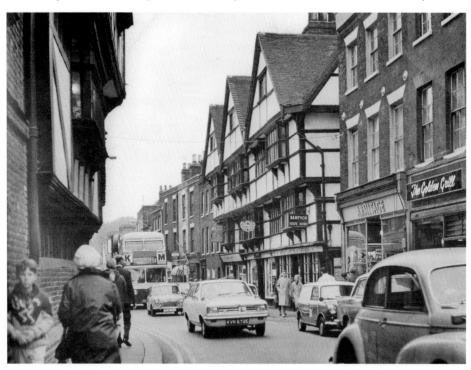

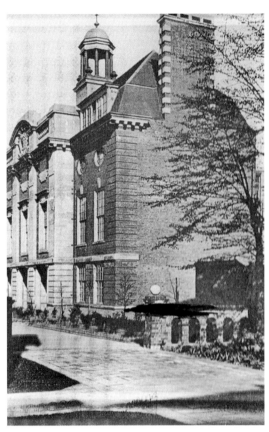

Rochester Library
This solid Edwardian building was originally designed as a technical school. Its designers, Russell and Cooper, embodied Tuscan-style features into the architecture, which were highly fashionable during this era. Later to become an adult education centre, it houses the library which moved from the 'newer' Corn Exchange, which in turn became the Registry office.

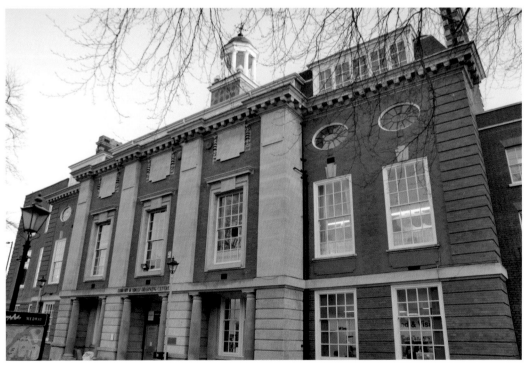

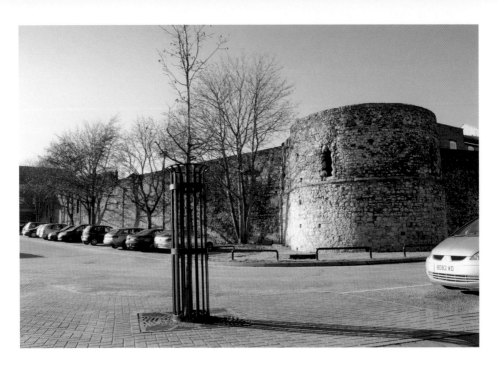

City Walls

The historian and archaeologist George Payne surveyed the city walls in 1895. His results published in *Archaeologia Cantitiana* proved that the original walls had been built by the Romans and enclosed an area of some 23 acres. The medieval structures pictured here, having survived in good condition, greet visitors with a reminder of Rochester's important historic heritage.

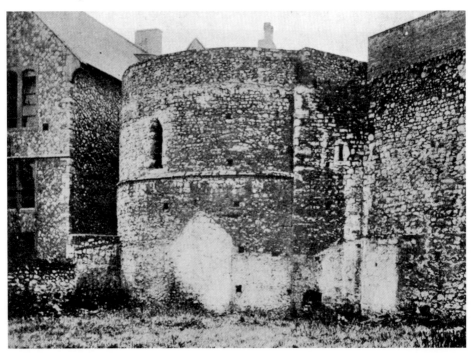

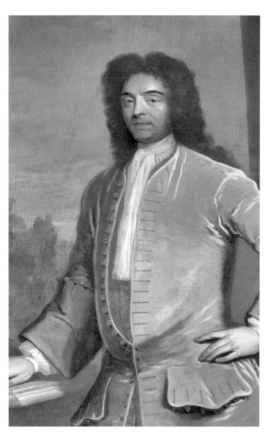

Sir Joseph Williamson

Sir Joseph Williamson was a prominent seventeenth-century civil servant, diplomat and politician. He was Member of Parliament for Rochester from 1690 to 1701. Using the considerable patronage his official position entailed he became very rich and powerful. His status at court, nonetheless, was sometimes controversial. However, locally his esteem was secured by his acquisition of the exceptionally desirable seat of Cobham Hall. Upon his death, he left a considerable fortune, with £5,000 allocated for endowment of a free mathematical school at Rochester. Pictured below is the entrance to the present school compound at Maidstone Road. However, the first school building was built near the city wall and superseded by a large Victorian 'pile' in 1894.

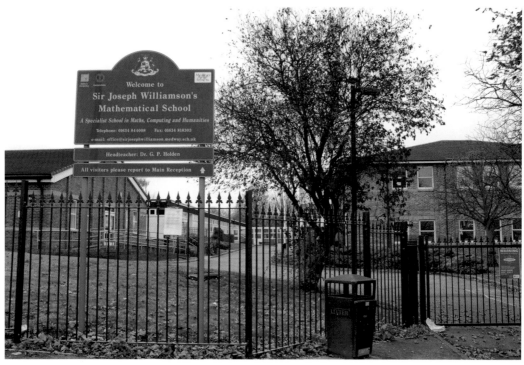

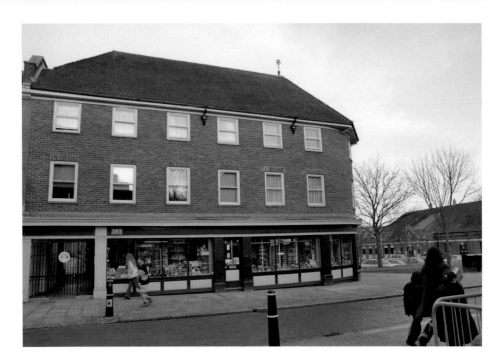

The Mathematical School, Rochester

An artist's impression of the old Victorian building belonging to the Maths School is shown below. After the relocation of the school to its present site in 1968, the High Street location was cleared to make way for shops. One early pupil of note was the famous actor David Garrick, who was briefly under the headmaster's tutelage. Others have achieved considerable success in the armed forces, industry and public service; however, they are all known somewhat humorously as 'old willies' after their founder Sir Joseph Williamson.

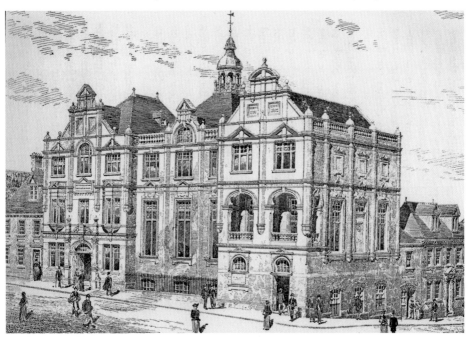

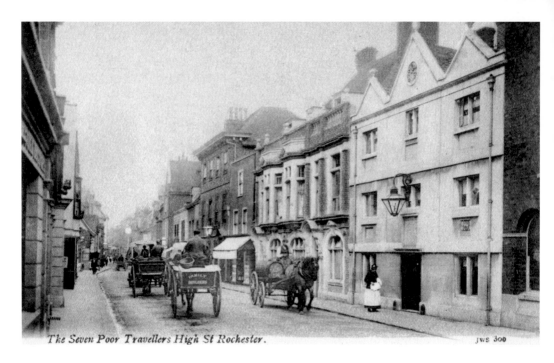

The Seven Poor Travellers High St Rochester. JWS 300

The Seven Poor Travellers House

A plaque on the wall of this unique charity describes how it was founded by a bequest from local MP Sir Richard Watts in 1579. The six free rooms lodged travellers overnight and were immortalised in Charles Dickens short story *The Seven Poor Travellers*. The seventh traveller was Dickens himself, who narrated the tale.

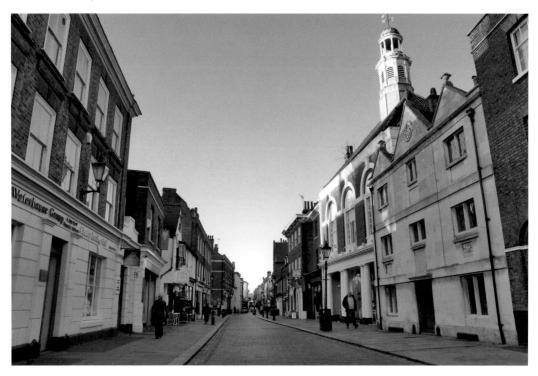

Poor Travellers Lodging Rooms

These views depict an annex to the Seven Poor Travellers house's small bedrooms. Basic accommodation was provided and so long as the occupants were neither rogues nor proctors they received four pence to help them on their journey. A herb garden is cultivated here and at Christmas, during Rochester's fancy dress Dickensian Christmas Festival, a turkey is cooked and distributed to the public.

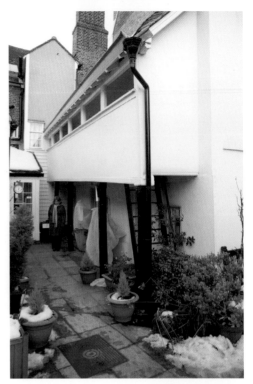

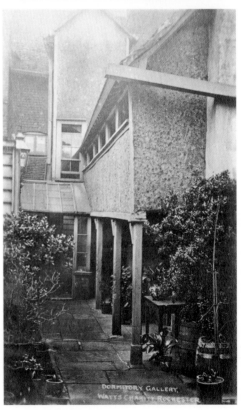

Sir Richard Watts

Sir Richard Watts was a successful businessman and MP for Rochester in the 1570s. He supplied rations for the English Navy and supervised the construction of Upnor Castle. Queen Elizabeth I was his guest in 1573. When he asked her if his house was to her liking she replied '*Satis*', which is Latin for 'enough'. The house hence adopted the name Satis and is now used by the Kings School as its administration centre. Watt's legacy was so munificent that it still exists today. One of its living bequests is the Almshouses, Maidstone Road. They are a fine example of Victorian cottage-style gothic, pictured below.

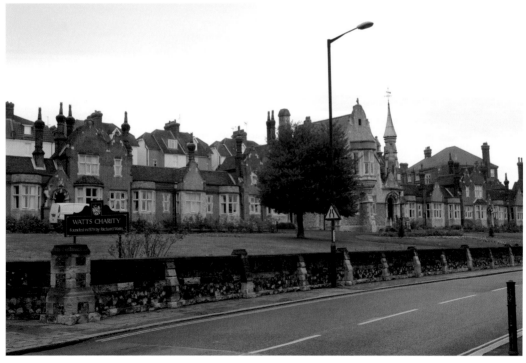

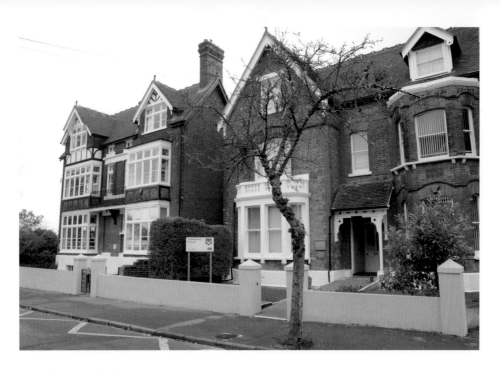

St Andrews School, Watts Avenue
Founded by Mr Davies, this private junior school has successfully existed at Watts Avenue for some sixty years. In the past there was an annex at Cunningham House, St Margaret's Street, and for a few years a move for senior pupils to Boxely House, near Maidstone. Robert Turcan is standing on the far right of the middle row, c. 1960.

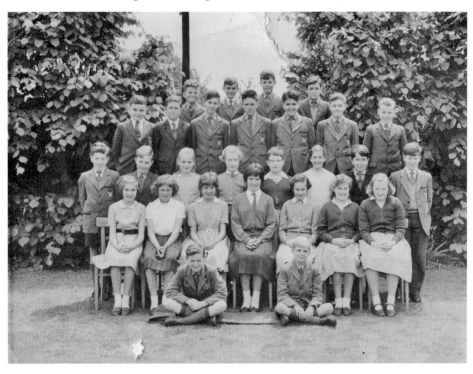

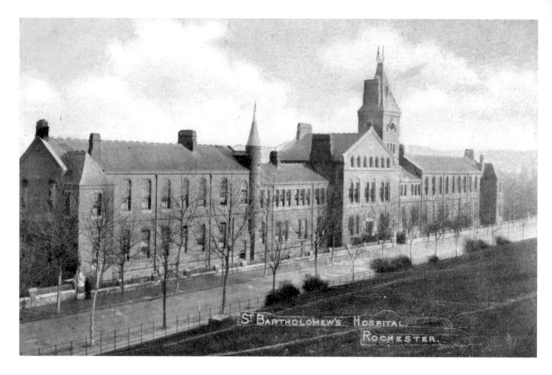

St Bartholomew's Hospital

St Bartholomew's Hospital is one of England's oldest hospitals, founded by Bishop Gundolf for the poor and leprous in 1078. The present building was erected south of the High Street at New Road in 1861, in typical Victorian-gothic style.

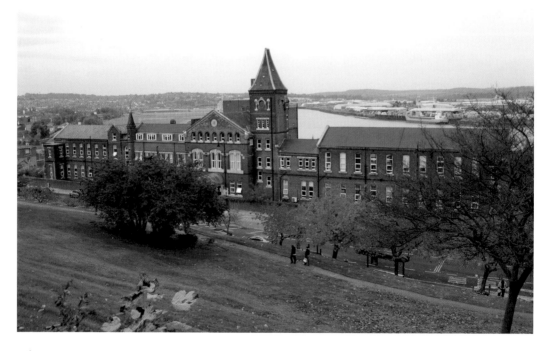

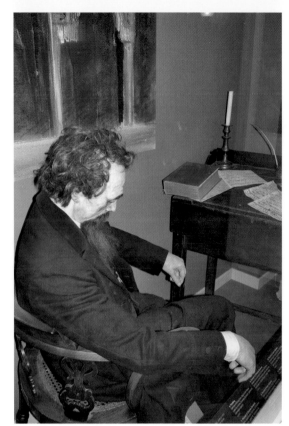

Charles Dickens

The snapshot opposite is of a waxwork model of Charles Dickens, resting from his literary exertions, in Rochester Museum. A far larger exhibition called Dickens World was opened in 2007. It covers 71,500 square feet of the former naval dockyard, Chatham, where his father once worked as a pay clerk.

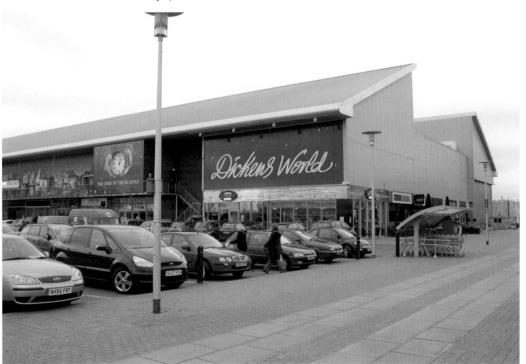

Gadshill House

The circumstance of how Gadshill House became Charles Dickens' country home has all the poignancy and romance of one of his great stories. As a nine-year-old boy he had admired the house while walking past it with his somewhat feckless father. He was told that if he worked hard he could eventually become the owner of such a property. Eventually his dream became a reality in 1856, at the peak of his career; he purchased this lovely Georgian home from Mrs Linton. In 1924, it became a school, and remains so today.

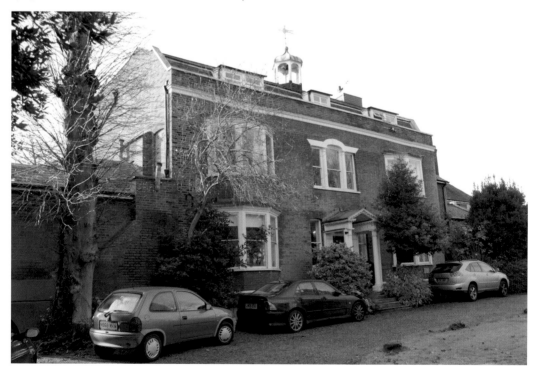

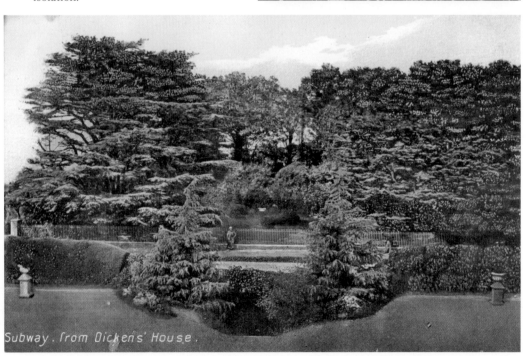

Charles Dickens' Chalet

At Christmas 1864, Charles Dickens' friend, the French actor Charles Fechter, presented him with a Swiss chalet in kit form. Dickens decided to have the ninety-four pieces assembled in a shrubbery the other side of the main highway at Gadshill. To gain access he obtained permission for a tunnel under the road. The old Edwardian postcards reproduced on this page reveal the place where Dickens escaped to seek creative isolation.

Dickens' Chalet

Subway. from Dickens' House.

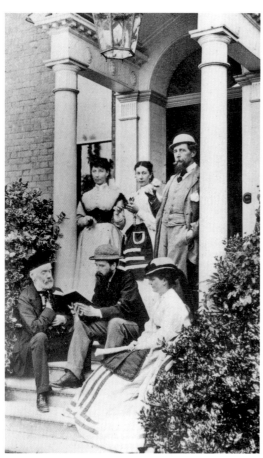

Images of Dickens' Domestic Life at Gadshill

Charles Dickens' relationships with members of the fairer sex were coloured by the emotional scar of his mother's insistence that, in his youth, he should help the family finances with a job of cruel drudgery. Also his first choice of partner proved disappointing when her parents rejected him as unsuitable. Eventually, however, a degree of domestic contentment can be discerned from these images of middle-aged prosperity at Gadshill.

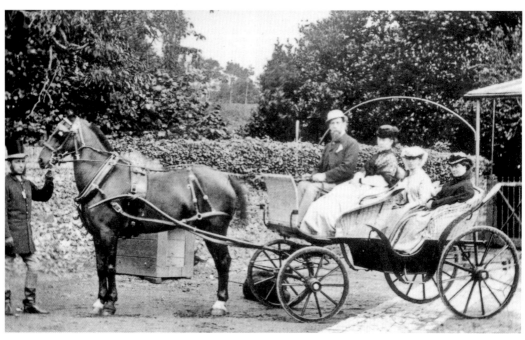

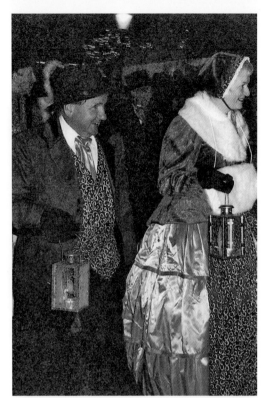

Rochester's Christmas Dickens Festival
The first weekend of December heralds
Rochester's Christmas Dickens Festival.
Local residents love to participate in the
various events as they enjoy dressing up in
Victorian fancy-dress costumes.

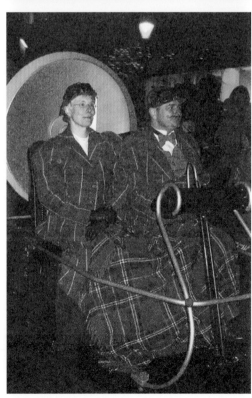

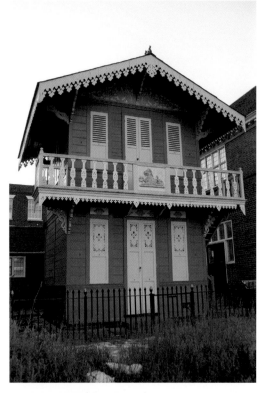

Dickens' Chalet, Rochester High Street
Dickens' Chalet, which he escaped to for writing his last novel, *The Adventures of Edwin Drood*, is preserved near Eastgate House and the public library. It is currently in need of a major scheme of repair and renovation. The top photograph shows its present condition, with a view of the return entrance to the tunnel linking it to its original site at Gadshill below. Over the archway is a stone plaque of a sad face, whereas in contrast, a happy physiognomy greeted him as he left his home to pen his beloved literary masterpieces.

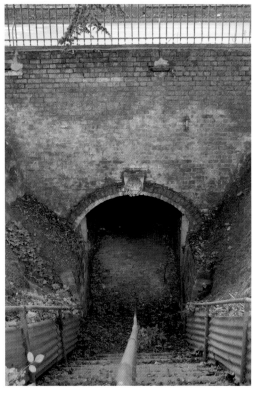

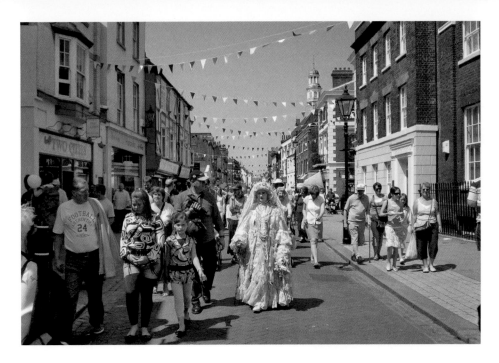

Dickens Festival

A major tourist attraction and fun day for locals is the annual Dickens Festival held in June. Dickens Fellowship Society members throng the streets dressed in colourful Victorian costumes. Mr Pickwick arrives by train and leads the procession to the castle grounds. The photograph above shows the spurned character Miss Haversham from *Great Expectations* (whose Satis House was based upon Restoration House) in her ragged wedding gown. Meanwhile a group of elegantly attired Victorian gents pose, below, before the almshouses for Huguenot immigrants.

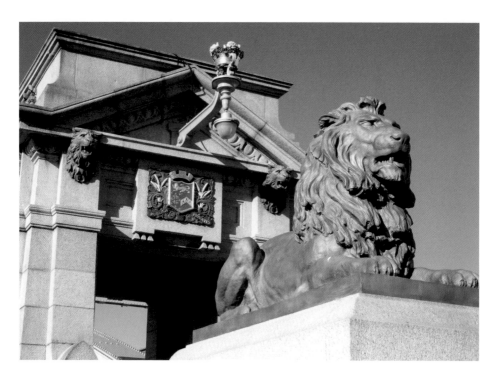

Two Redoubtable Faces of Rochester
This Landseer-like lion *en passant* greets travellers on their passageway over Rochester Bridge. The more devilish, bearded, face below was pictured at the Sweeps Festival on May Bank Holiday.

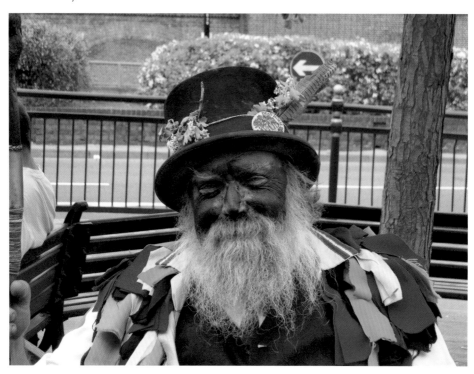

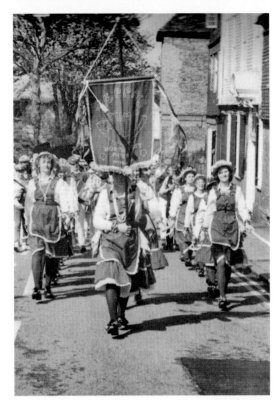

Sweeps Festival

Rochester Sweeps Festival has become the largest May Day celebration of its kind in the country. Its origins go back to before the Climbing Boys Act of 1868 – making it illegal to employ young boys to clean chimneys. Revived by Gordon Newton and now organised by Medway Council, this annual parade attracts some sixty Morris-dancing bands to enliven this traditional ceremony.

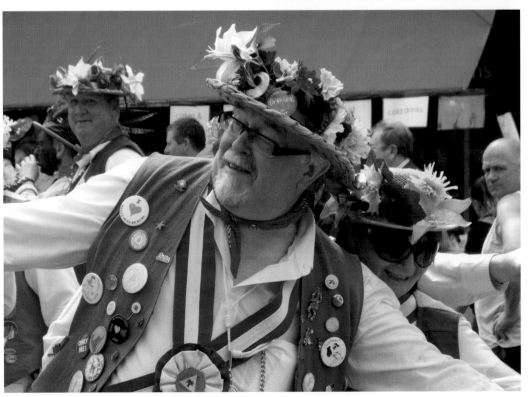

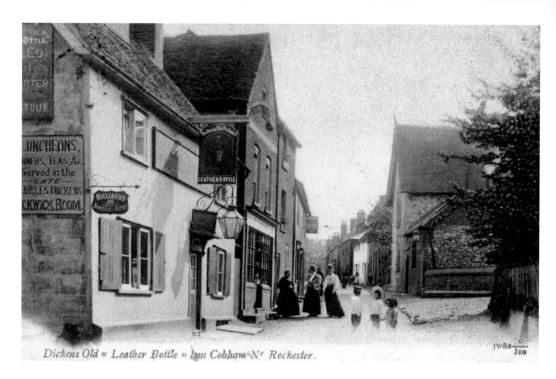

Dickens Old « Leather Bottle » Inn Cobham Nr Rochester.

JW&s
310

The Leather Bottle, Cobham

The Leather Bottle derives its name from a leather bottle containing sovereigns found there in 1720. It was a favourite haunt of Charles Dickens who featured it in his novel *Pickwick Papers*.

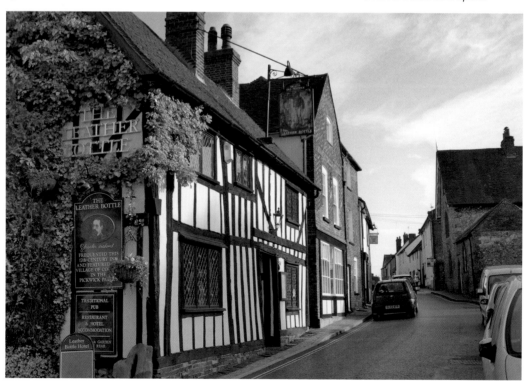

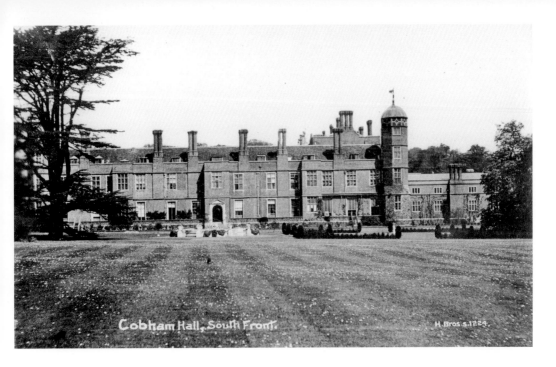

Cobham Hall, South Front. H.Bros.s.1224.

Cobham Hall

This glorious country mansion has a distinguished history going back to 1200. Around the late seventeenth century, it was the seat of Rochester's benefactor, Sir Joseph Williamson MP. Later, it was owned by the Earls of Darnley. The eighth earl was famous for leading the English cricket team to victory against Australia in 1883. In fact The Ashes, which symbolise this contest, were kept in their urn on his mantelpiece here for many years. Now the house and grounds provide a splendid setting for an esteemed private girls' school.

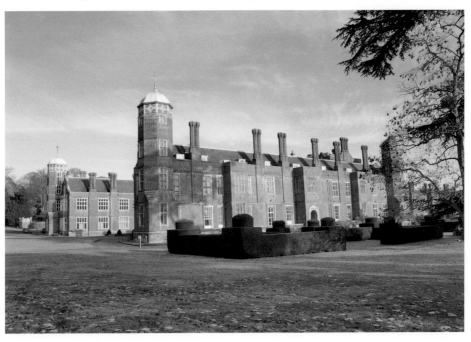

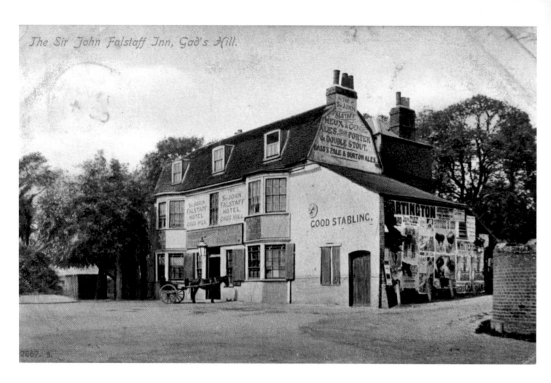

The Sir John Falstaff Inn

A tavern from time immemorial, the Sir John Falstaff was named after Prince Hal's lovable rogue and old friend. The model for this colourful Shakespearian character was Sir John Oldcastle, who upon his marriage became Lord Cobham. The picaresque robbery scene from *Henry IV* is set here. It was also where Dick Turpin staged some of his notorious crimes against rich travellers.

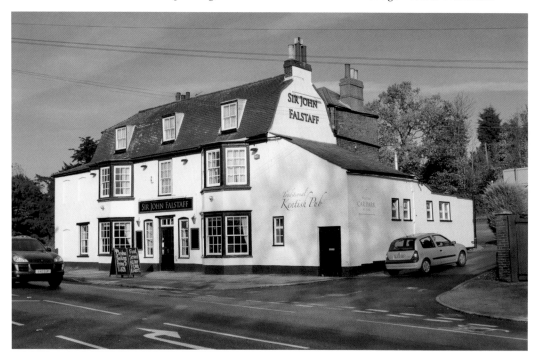

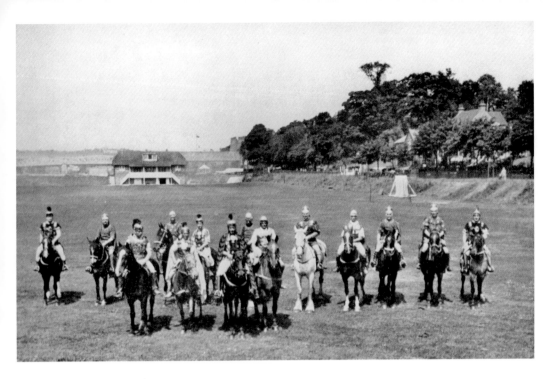

Rochester Historical Pageant, 1931

Rochester Historical Pageant of 1931 was a most ambitious project, as it was staged at the height of the Depression and involved a cast of some 5,000 people. Past historical events were performed before large audiences. HRH Prince George was invited to the opening ceremony and Dame Sybil Thorndike played the part of the Spirit of Rochester. The scenes here depict the scale and professional standard of this event, which was of such importance that it was reported in national newspapers.

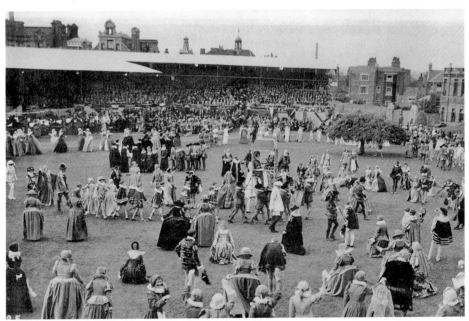

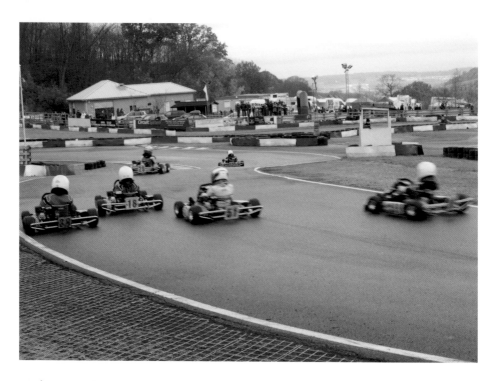

Modern Sporting Events

Modern outdoor sport in or around Rochester is pictured here. Above, Buckmore Park, near the M2 motorway, boasts a challenging go-kart track. Below, the view depicts streets of the borough which were recently used for part of the famous Tour de France cycle race.

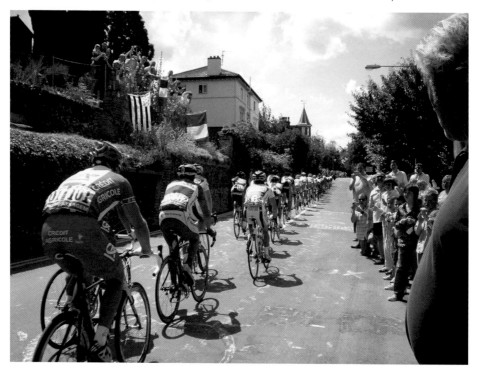

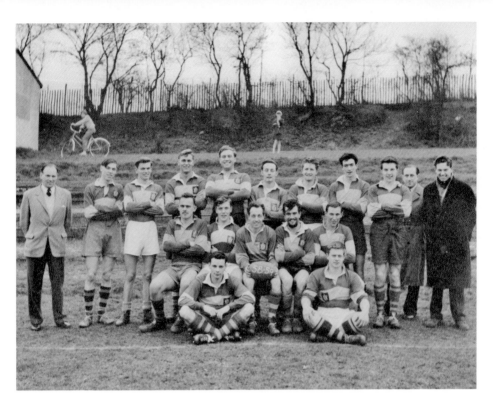

Medway Rugby Football Club
Above is a 1958/9 formal photograph of the first team. Their Captain, Wally Elvy, is seated holding the match ball. Whereas below, is a snapshot of his glamorous wife, Daph, at a club dance – joining in the fun of a 'conga'.

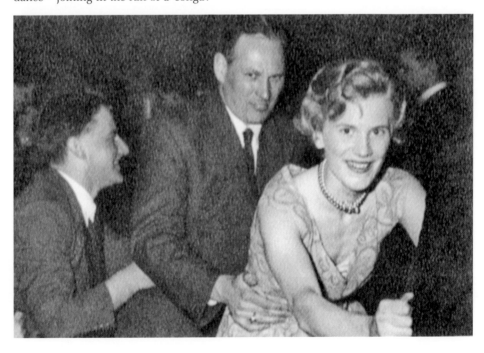

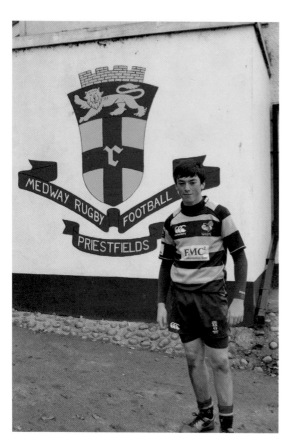

Current Images of Medway Rugby Football Club
The Priestfields headquarters of Medway Rugby Football Club exudes an atmosphere of purposeful fun and relaxation. It is a happy Saturday venue for scores of Rochester's young men – such as those pictured here at the entrance and clubhouse bar.

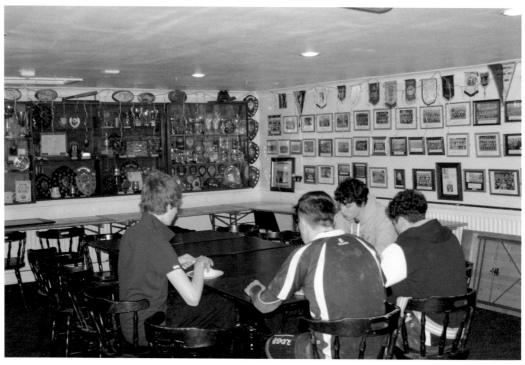

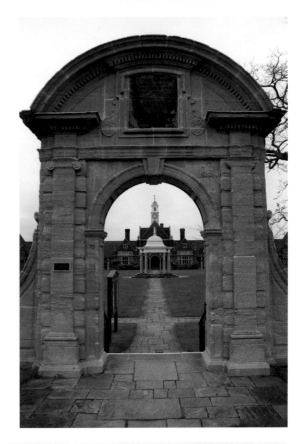

Foord's Almshouses I
Opened by HRH Prince Arthur of Connaught in June 1927, these almshouses were the bequest of Mr Thomas Foord. Although a resident of Hampshire, his family had long associations with the city. During his lifetime, he gave large sums of money towards restoration of the cathedral, St Bartholomew's Hospital and the museum.

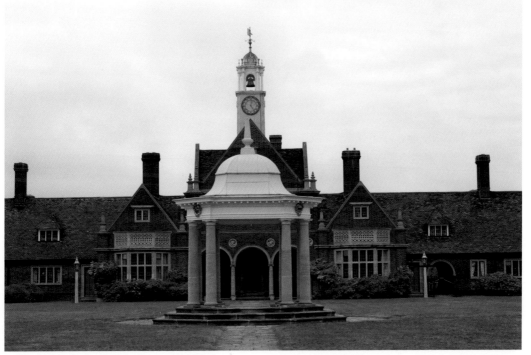

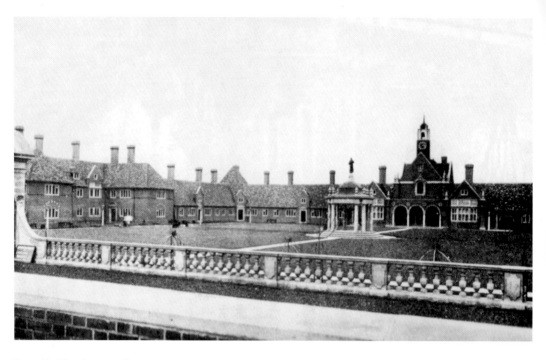

Foord's Almshouses II
The grace and elegance of the design by architect E. Dawber shows a refinement rarely achieved by today's builders of sheltered housing for the elderly. Its visual impact is helped by the elevated landscape at Maidstone Road near the Priestfields.

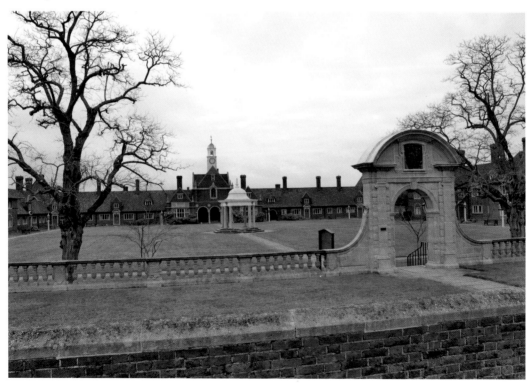

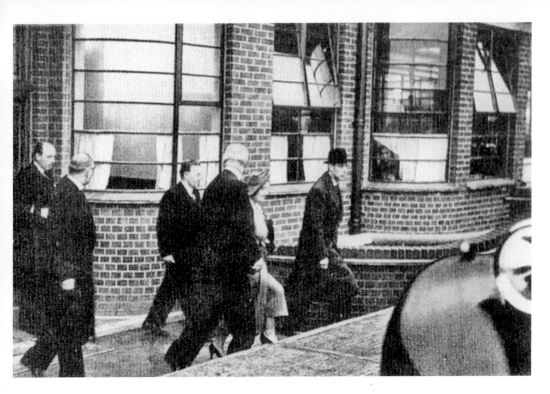

King George VI's Visit to Short Aircraft Factory
With the threat of war looming and the widely held belief that aviation would play an increasingly important role in combat, King George VI paid a visit to the Esplanade works of Short Bros. During the Second World War, Rochester became one of Kent's front-line RAF airfields. It was the target of many Luftwaffe raids, but the picture below shows an American P47 Thunderbolt, which had crashed into the canteen while landing without brakes.

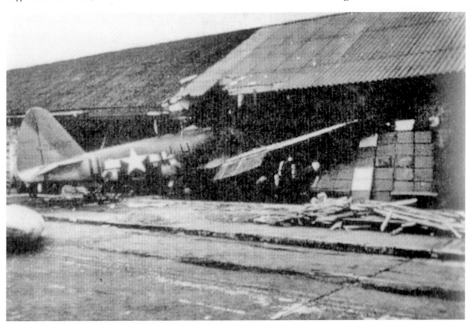

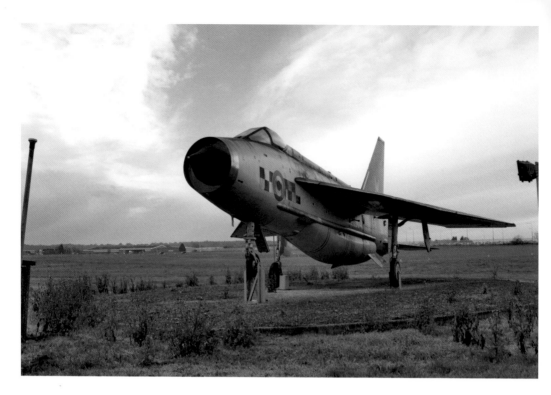

Rochester Airport

In 1933, Rochester Council purchased a large area of land on top of the North Downs alongside the Chatham–Maidstone road with the idea of establishing a municipal airport. Soon afterwards, Short Brothers leased the land for test flying purposes. After the Second World War, a flying school was established as shown in the old photograph below. Above is the fabulous English Electric Lightning fighter plane, which achieved unprecedented supersonic speeds. GEC, who merged with English Electric, manufactured many of the components for this advanced plane during the Cold War era, at their nearby avionics factory.

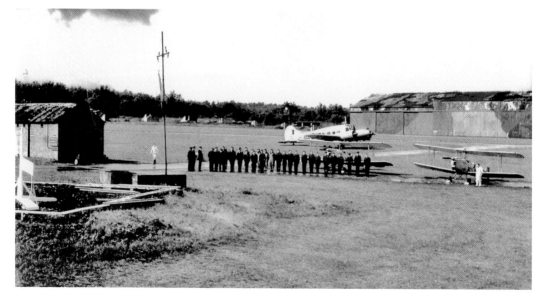

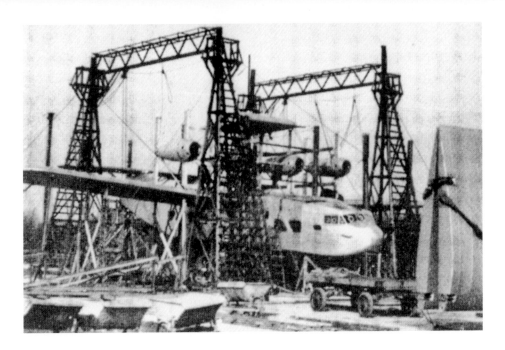

Aircraft Industry Rochester

Short Brothers were the world's first commercial aircraft manufacturers. Their early machines were made on the Isle of Sheppey at Eastchurch. However, with the introduction of sea planes they moved their operation to Rochester. The picture above illustrates the construction of a 1930s flying boat, while the aerial picture below shows the present extent of BAE's current activities adjacent to Rochester Airport.

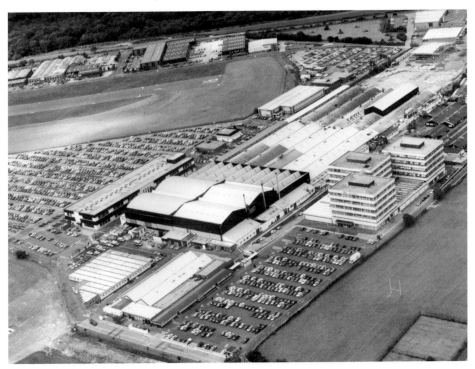

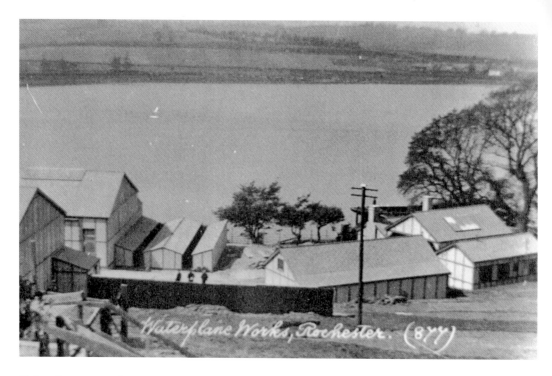

Flying Boats at Rochester

Short Brothers' Water Lane Works, Rochester, was sited alongside the banks of the River Medway to facilitate launches. The picture above shows their modest beginnings. Nonetheless, the advanced, for its time, sea plane seen touching down before Rochester Castle is a typical example of the machines that were developed here and sold around the world.

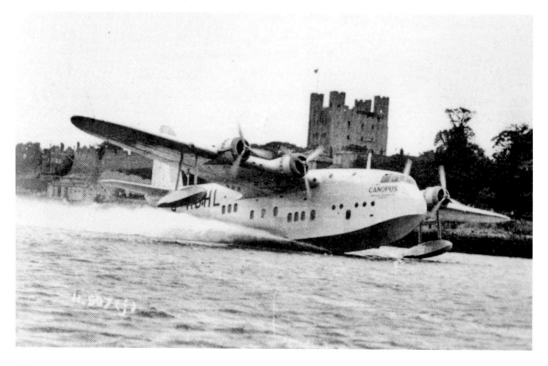

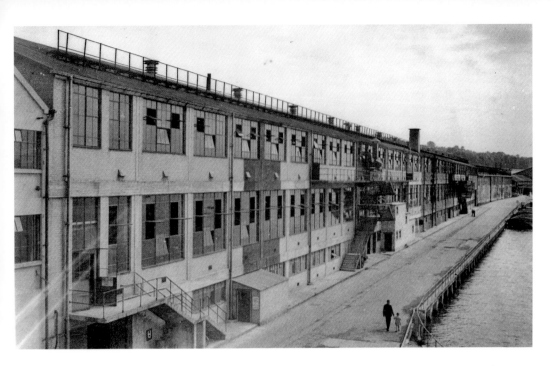

The Esplanade

To meet the demands for aircraft components during the Second World War, Short Brothers developed factories alongside the River Medway. To fight potential fires caused by incendiary bombs, concrete barges containing sea water were moored at the quayside. Now this area has been completely redeveloped into attractive executive-style flats.

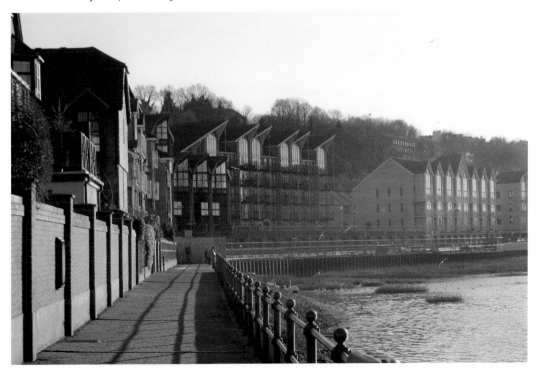

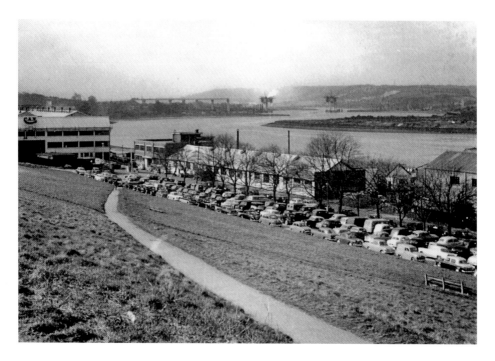

The Backfields

This steep grassy bank was donated to the city by Councillor Charles Willis for use as a recreation ground in 1906. The old photograph shows CAV's factory and workers' car park at the bottom of the slope before it was demolished for brown-field redevelopment as dockside homes.

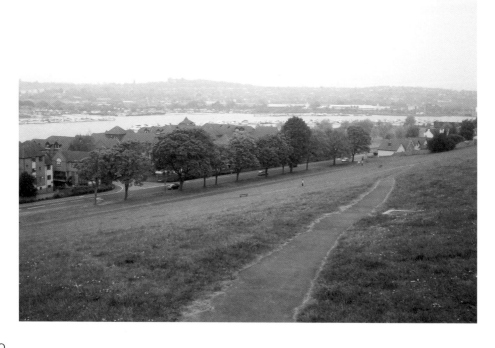

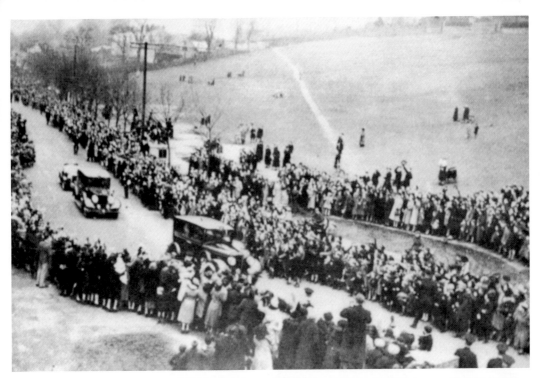

Royal Visit to Short Brothers
The cavalcade of cars carrying George VI on his visit to Short Brothers' works on 14 March 1939 passes crowds of loyal supporters. Nearby a plaque now marks the site of the old works, which has been completely cleared for modern housing.

The Short Brothers
Horace, Eustace and Oswald
aviation pioneers and their workforce
founded Britain's aircraft seaplane
and flying boat industry
Isle of Sheppey 1908
Rochester 1914-1948
SHORT BROTHERS COMMEMORATION SOCIETY 2008

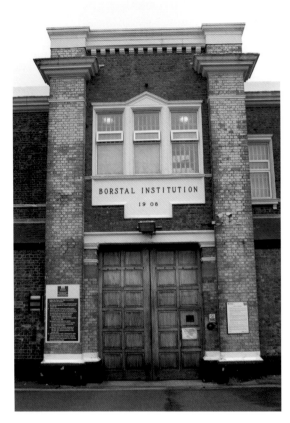

The Borstal Institution

The first Borstal was built at Borstal village on an old military site. It was the prototype for youth prisons, which offered education and regular work as a means of rehabilitation away from hardened criminals. The foreboding entrance to the original institution, built in 1906, is illustrated here.

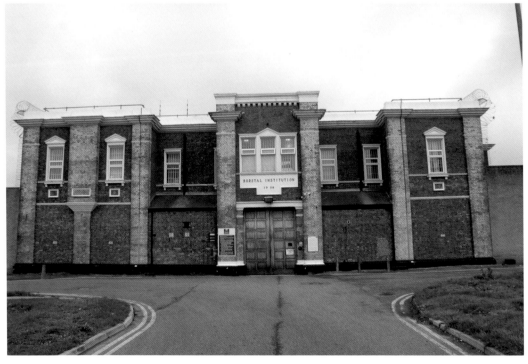

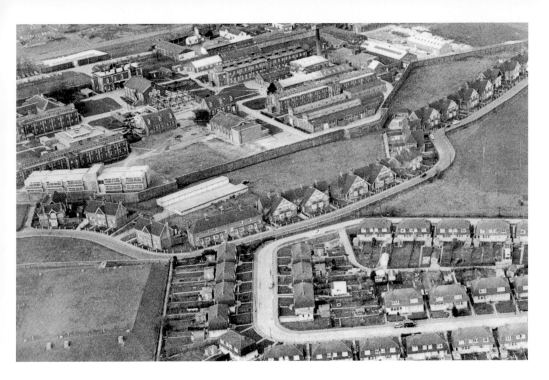

Old Views of Borstal

The aerial picture above gives an overview of the Borstal Institution in the 1930s, with a nearby housing development. Below is a glimpse of part of the derelict Borstal Fort. It was built between 1875 and 1885 on land south-west of Rochester to a polygonal design by convict labour. Although never actually armed, it did, however, become the site of an anti-aircraft battery during the Second World War.

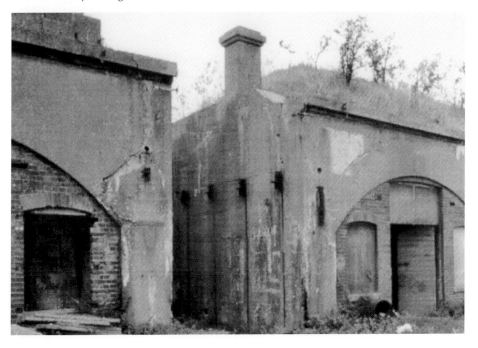

Halling

A few miles upstream from Rochester, a Saxon tribe called the Hallingas settled. The manor was owned by the see of Rochester and is where the bishops built a palace overlooking the river – a convenient boat trip away from the cathedral. Once a splendid residence with vineyards, Black, in his mid-Victorian guide, describes how, after the churchmen left, it suffered 'from the corroding touch of time'.

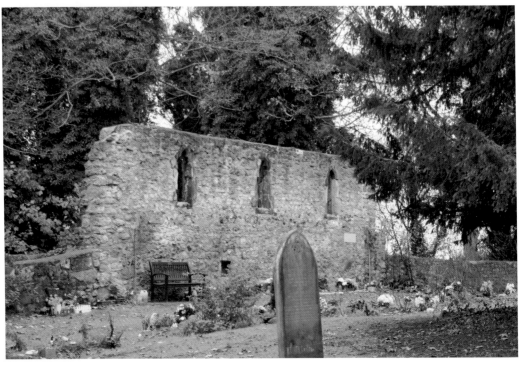

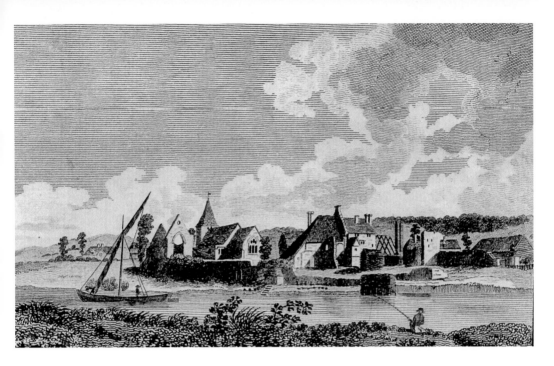

Bishops Palace, Halling

Halling Episcopal Palace was already in an advanced state of decay when the etching for the above eighteenth-century print was produced. The small, mainly Early English, church alongside remains in good use today. Meanwhile, the plaque below marks the local cement manufacturer's generosity in funding restoration of the palace ruins.

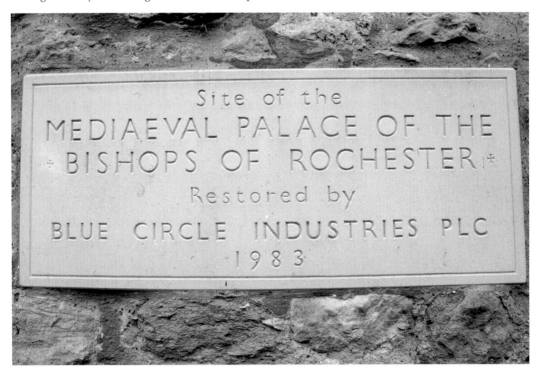

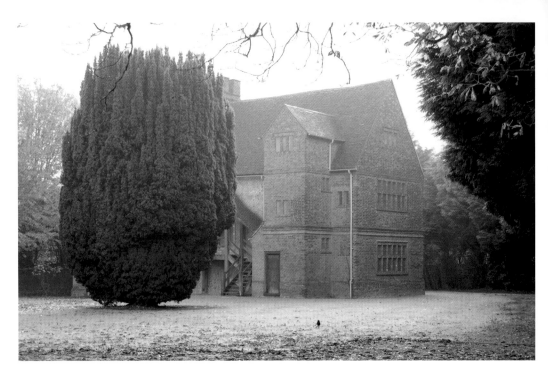

Temple Manor, Strood

Tucked away amid an industrial estate stands Temple Manor. Surrounded by strong security fencing, the photograph above, taken with the early morning shroud of mist arising, was only possible through an aperture where a padlock was attached. Built in the early Middle Ages, this hostel provided accommodation and fresh horses for the Knights Templars – a band of soldiers who protected pilgrims on their journey to the Holy Land.

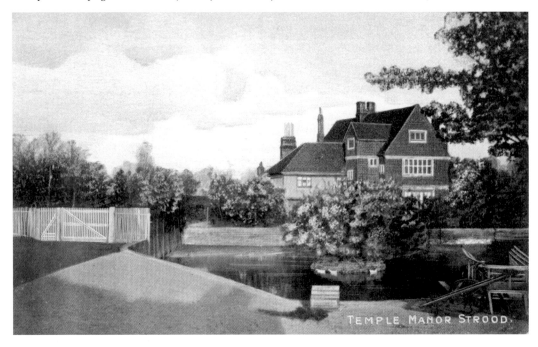

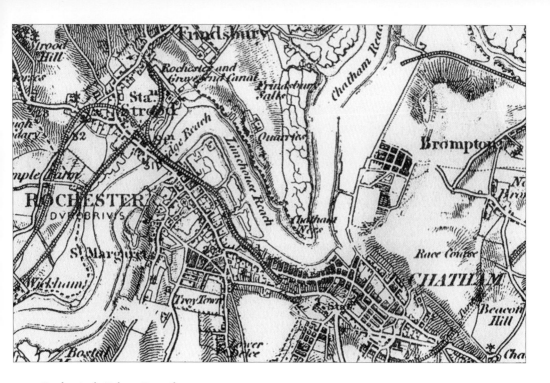

Rochester's Urban Growth

The Medway towns have a current population of around a quarter of a million. The maps juxtaposed here, from early nineteenth to mid-twentieth centuries, illustrate the pattern of some of this growth. The older map shows Troy Town and the lower Delce surrounded by fields, which have now become engulfed by houses. A racecourse was even extant on land that since became Gillingham.

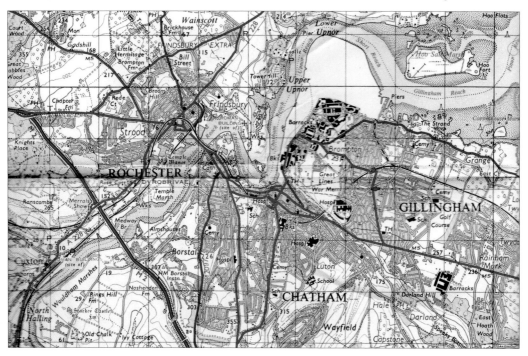

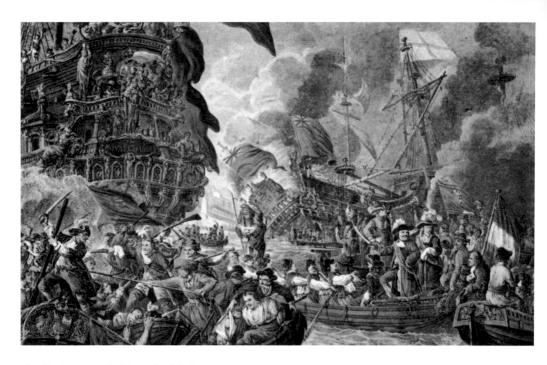

Van De Ruyter's Raid on the Medway

The Dutch mounted an audacious naval attack on the Kent coast in 1667. After destroying the partly built fort at Sheerness, they sailed on to Gillingham where they broke a defensive chain across the river. They then ran the gauntlet of artillery from Upnor Castle and succeeded in destroying a number of English ships. Lastly, the *Royal Charles* and the *Unity* battleships were taken away as bounty.

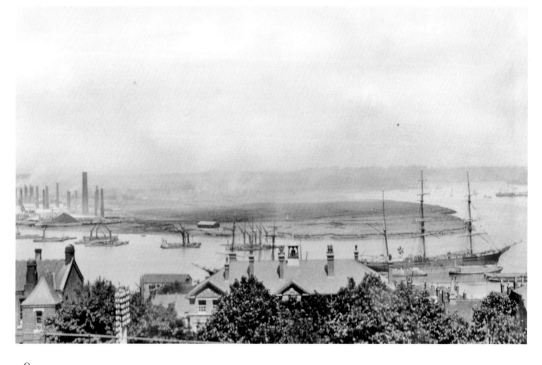

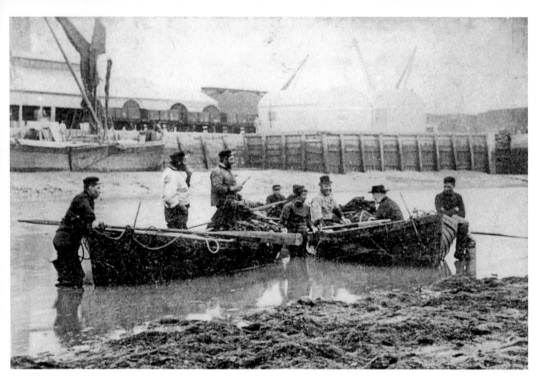

Rochester's Watermen

The character and type of men who gained their livelihood from working on the River Medway is well portrayed by the Victorian snapshot above – side-whiskers, beards and peaked caps were the order of the day. Below, however, a more formal scene is depicted at the annual Admiralty Court on board a barge, where officials, in cocked hats, set the rules for the coming fishing season.

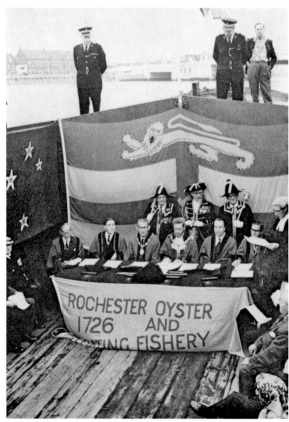

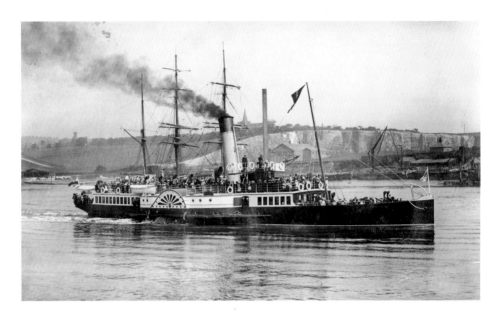

Paddle Steamers

The *City of Rochester* was the last and largest of the paddle steamers bought by Medway Steam Packet Company for service on the east coast. She weighed 235 gross tons and was broken up for scrap in 1938. The *Medway Queen*, however, had a better fate. She distinguished herself at the evacuation of Dunkirk in the summer of 1940. A near record of seven voyages saved the lives of thousands of allied troops including those from the *Brighton Belle*, which sank alongside on a return journey. Now rescued from being a clubhouse at the Isle of Wight, this famous vessel is seen below on a floating dock being restored with funding partly provided by the National Lottery.

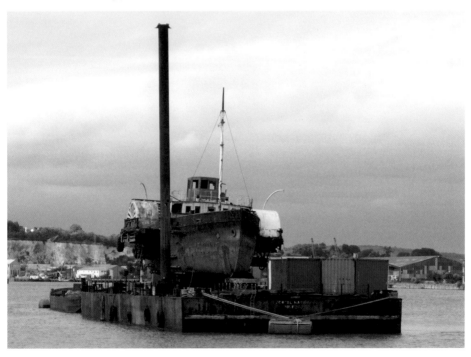

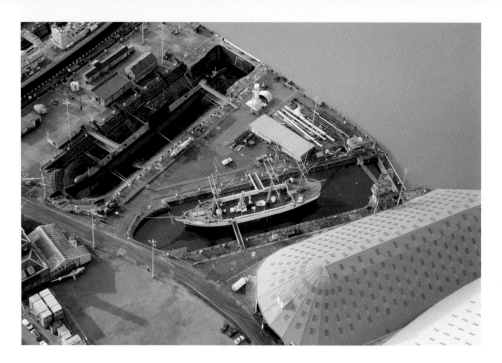

The Royal Navy Dockyard, Chatham

Although the Naval Dockyard base was largely constructed in the borough of Chatham, it had a powerful influence on the neighbouring and more ancient town of Rochester. The picture above shows HMS *Gannet* (a Victorian warship) in dry dock. It is visited by thousands of tourists who come to visit the many interesting exhibitions celebrating this site's history of ship building and provision. Below, the local well-known and respected aerial photographer Richard Smith has captured a shot of the mouth of the docks and sweep of the River Medway upstream to Strood.

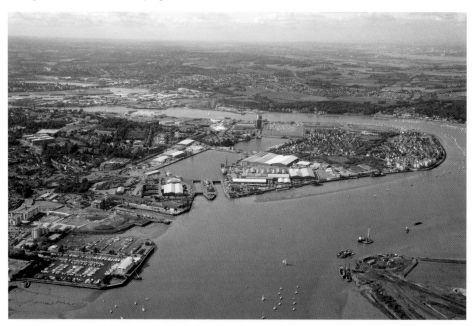

River Traffic

In the eighteenth century, there was a vigorous trade at the port of Rochester. Inward cargoes consisted of coals from Yorkshire, grain and dairy products from East Anglia, and general haulage from London. Outward goods were principally fruit, hops and other agricultural crops, plus Fuller's earth. Along with the general shipping portrayed in the painting below by Joseph Farington in 1790 can be seen prison hulks moored in the foreground. Today, virtually all commercial boats have vanished from this stretch of the Medway. However, in the tranquil scene above, two competitors in the Lord Mayor's cruise of 2010 can be seen gliding along in light breezes.

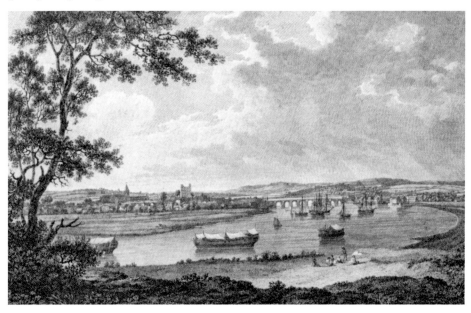

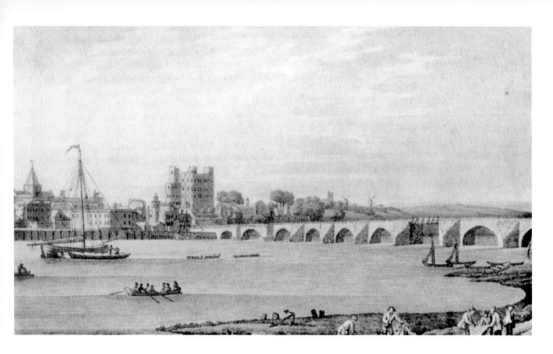

Old and New Bridges over the Medway

The stone bridge in the copperplate print above was built by Sir John de Cobham and Sir Robert Knollys in 1388. The latter was a military leader who rose from humble origins to succeed with the Black Prince in campaigns in France and to lead the forces crushing Jack Straw's rebellion in London. The latest crossing, pictured below, is a rail bridge for the high-speed (up to 200 mph) train, which links England to France.

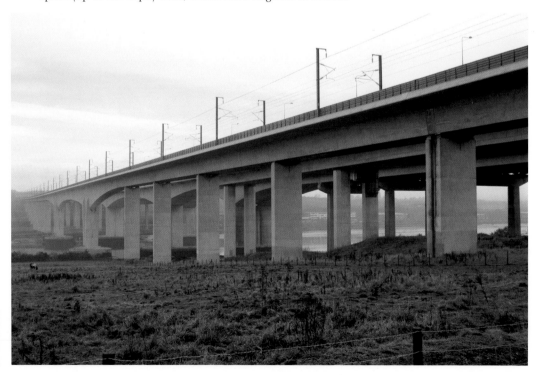

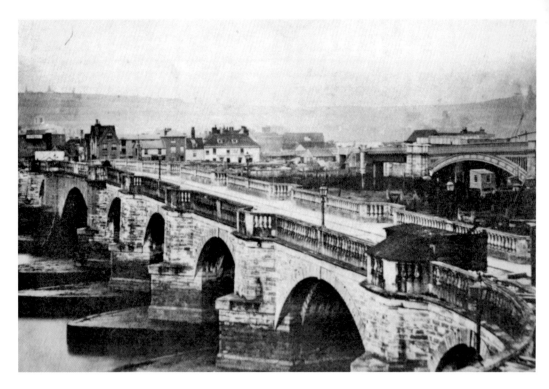

Toll Roads

For many years tolls maintained the old medieval Rochester Bridge, which survived until 1857 (just long enough to be photographed). The toll gate at Strood was erected in 1769 to fund pavement and road improvements. It lasted until 1876, when it was removed by the bridge wardens who were simultaneously handing over their duties to the corporation.

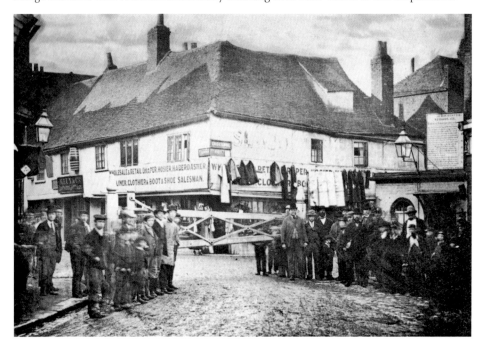

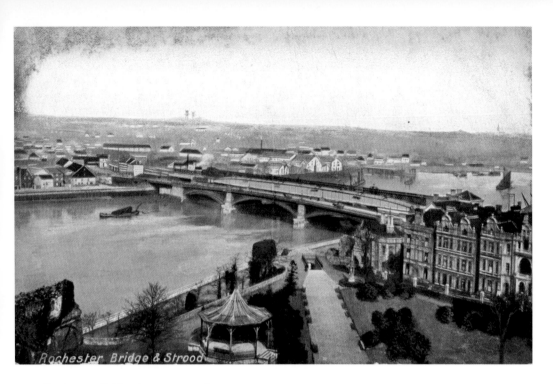

Rochester Bridge & Strood

Rochester Bridge Improvements

After the previous stone bridge of antiquity was removed by the Royal Engineers using innovative explosives, the crossing pictured above was constructed. It was, however, modified in 1911, when the lower arches were removed to allow larger shipping to pass underneath.

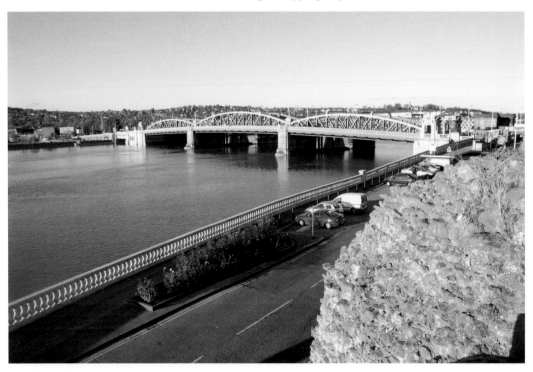

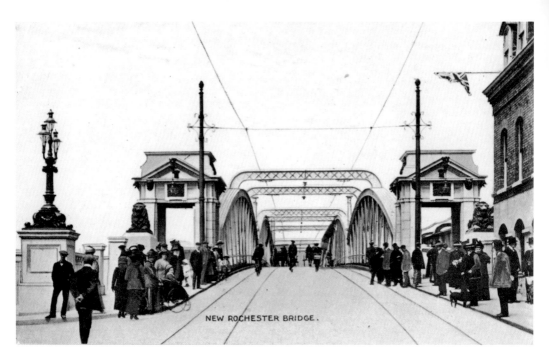

NEW ROCHESTER BRIDGE.

'New' Rochester Bridge

Edwardians built things to last and the two pictures on this page illustrate this well with virtually no changes to this robust structure with exactly a century of use.

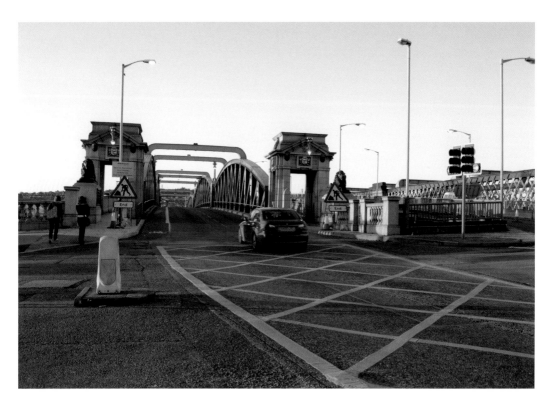

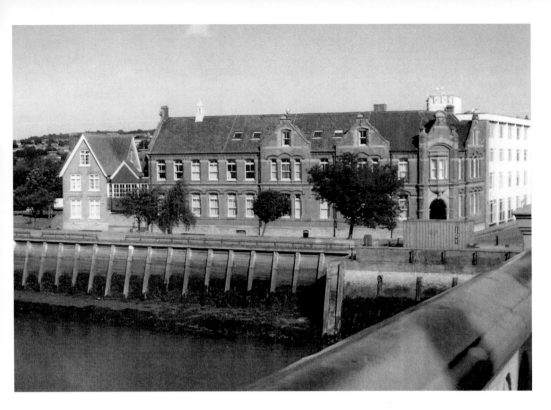

Heavy Engineering Works, Strood

The handsome brick façade to Wingates factory is shown below. The site had previously been the headquarters of steam engine manufacturers Aveling & Porter, before their move to the north of England. Eventually, Medway Council used these premises for offices before they became redundant and were sadly demolished.

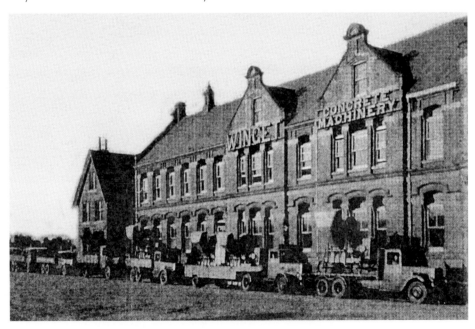

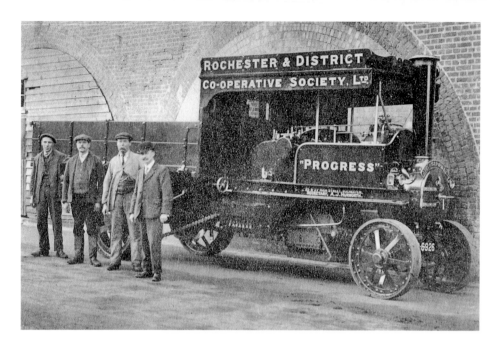

Aveling and Porter Steam Engines

Thomas Aveling was a farmer with a passion for building steam-driven ploughs. After forming a partnership with Porter, many different types of traction engines, steam rollers and other contraptions were designed and sold to a rapidly growing home and overseas market. Over ten thousand steam rollers were produced and transformed methods of road maintenance and construction worldwide. The above engine found a local use with Rochester & District Co-operative Society Ltd, while the compact tractor below was used for military purposes at the nearby Chatham barracks.

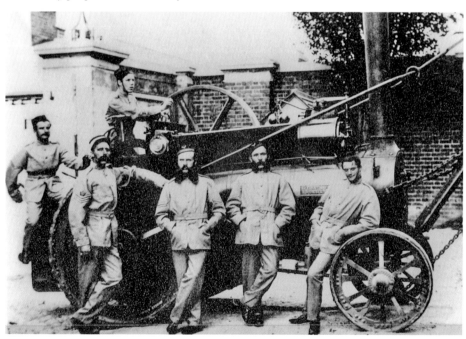

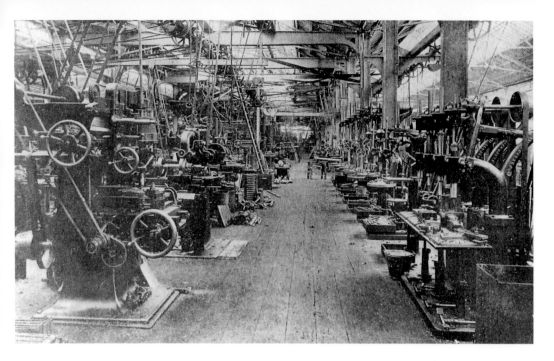

Engineering Works

The Medway town's renown for top quality engineering work was to a large extent established by Aveling & Porter and innovations demanded by armament improvements at the Naval Dockyard, Chatham. The rows of precision lathes at Aveling & Porter's works, Strood, are shown above. While a sea of cloth capped 'metal bashing' workers are seen below emerging from a day's hard work.

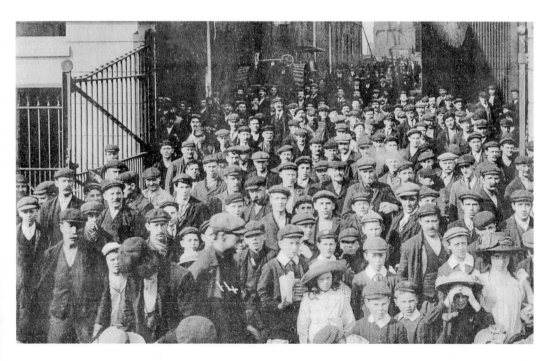

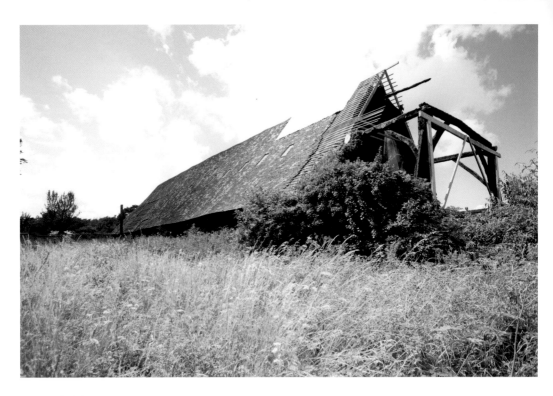

Frindsbury Manor Barn

Frinsbury is now mainly a suburb of Rochester, but this peninsula north of the city was in the Middle Ages a farming area and then of significant industrial importance. The 210-foot-long Manor Barn was designed to hold tithes paid in kind by landowners to the diocese of Rochester. It was miraculously saved from a damaging fire by the local brigade who temporarily abandoned their industrial action to save this heritage building.

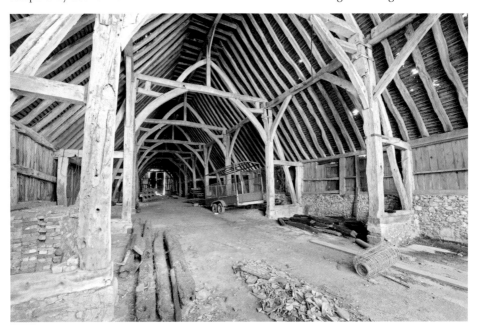

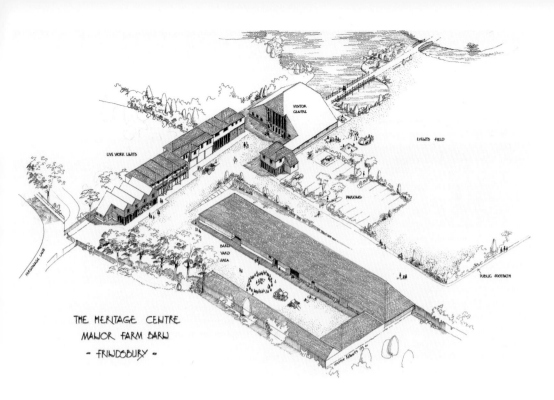

THE HERITAGE CENTRE
MANOR FARM BARN
- FRINDSBURY -

Planned Restoration and Redevelopment of Frindsbury Manor Barn

Sympathetic property developers have acquired Frindsbury Manor Barn and have exciting plans for its restoration and redevelopment into a heritage centre. A view of its parlous state of preservation is shown below. Meanwhile, an architect's impression of how this site could be transformed into a local asset is indicated above.

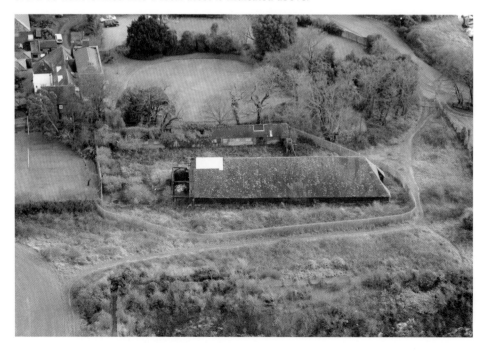

Upnor Castle

As England's naval power and prestige expanded in the Elizabethan era, need for the defence of shore-based facilities increased. Thus Upnor Castle was built at a strategically important point on the River Medway near Rochester and Chatham. The unique design of its battlements and gun emplacements can be appreciated from the overhead shot below.

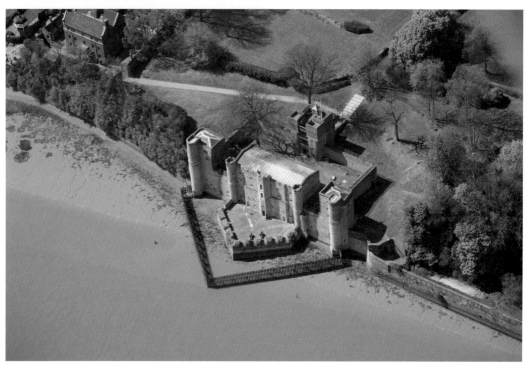

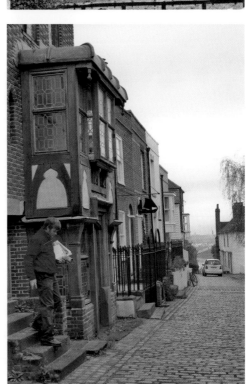
Upnor Hills, near Rochester

Village Scenes at Upnor
The village of Upnor is still surrounded by wooded hills like those depicted in this Victorian postcard. However, the main street that runs down to the water's edge is now transformed into a quaint village street. The reproduction period features of the building below were painstakingly crafted by its present owner who, nonetheless, now seeks to move on.

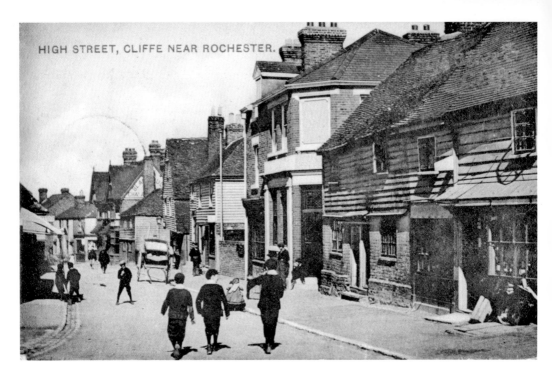

HIGH STREET, CLIFFE NEAR ROCHESTER.

Cliffe

The village of Cliffe lies north of Rochester on the Hoo peninsula. Much of the parish consists of fertile arable and fruit growing lands. Its name derives from its topographical situation on a chalk cliff overlooking marshes stretching out towards the Thames estuary. The main street has changed little over a hundred years save for the nature of traffic.

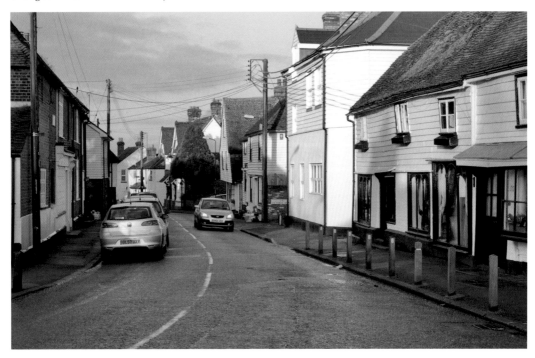

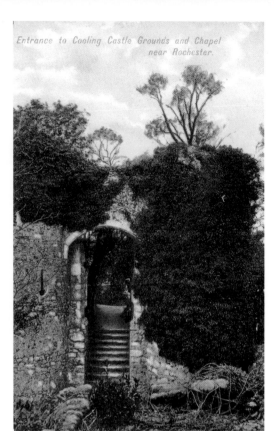

Entrance to Cooling Castle Grounds and Chapel near Rochester.

Cooling Castle

Cooling Castle was built in 1380 by John Cobham. His descendant Lord Cobham was besieged here by the rebellious Thomas Wyatt in 1554. At one stage this castle was also the home of the Lollard leader John Oldcastle, who was executed for his beliefs. Now the residential part is occupied by the musician Jools Holland and the majestic barn is used for wedding receptions.

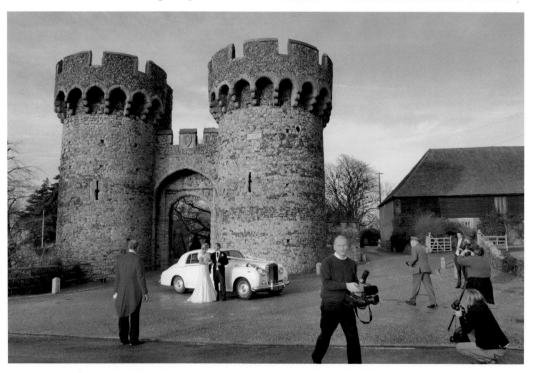

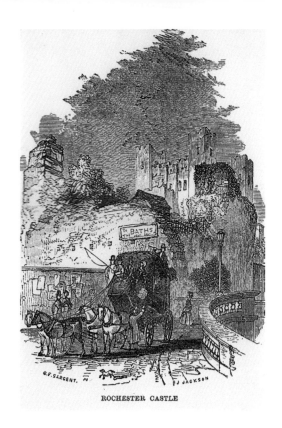

ROCHESTER CASTLE

'It is a far, far better thing that I do, than I have ever done;
it is a far, far better rest that I go to, than I have ever known.'

Charles Dickens – *A Tale of Two Cities*

Acknowledgements

Thanks go to Charlotte Turcan, Jocelyn Springett, Anthea and Brian Springett, Lawrence Springett, and Rochester and Sittingbourne libraries. A special debt of gratitude is owed to Tracy Bridge and Richard Smith for their generosity in giving free use of their photographs. Lastly, appreciation is given to local journalist and cricket aficionado Tony Rickson, for his unstinted time proof-reading.